FAN PHENOMENA

STAR TREK

EDITED BY
BRUCE E. DRUSHEL

Credits

First Published in the UK in 2013 by Intellect Books,
The Mill, Parnall Road, Fishponds, Bristol, BS16 3JG, UK

First Published in the USA in 2013 by Intellect Books,
The University of Chicago Press, 1427 E. 60th Street,
Chicago, IL 60637, USA

Copyright © 2013 Intellect Ltd

Editor: Bruce E. Drushel

Series Editor and Art Direction: Gabriel Solomons

Copy Editor: Emma Rhys

Inside front cover image: Leonard Nimoy and
William Shatner in 1968. © NBC Television
Inside backcover image: Star Trek MegaCon 2010.
© Mister-Loverpants

A Catalogue record for this book is available from
the British Library

Fan Phenomena Series
ISSN: 2051-4468
eISSN: 2051-4476

Fan Phenomena: Star Trek
ISBN: 978-1-78320-023-8
ePUB ISBN: 978-1-78320-100-6
ePDF ISBN: 978-1-78320-099-3

Printed and bound by Bell & Bain Ltd, Glasgow

intellect

Contents

5—9
Introduction:
The Exemplar of Fan Culture?
BRUCE E. DRUSHEL

10—19
Live Long and Prosper:
How Fans Made *Star Trek* a Cultural Phenomenon
ELIZABETH THOMAS

20—29
Not Your Daddy's *Star Trek*:
Rebooting a Franchise and Rewriting a Fandom
CATHERINE COKER

30—41
A Utopia Denied: *Star Trek* and its Queer Fans
BRUCE E. DRUSHEL

42—51
Trek in the Park:
Live Performance and *Star Trek* Fan Culture
MICHAEL BOYNTON

52—61
Assimilate This! Computer-Mediated Communication
and *Star Trek* Fan Culture
KIMBERLY L. KULOVITZ

62—71
Lost in Orbit: Satellite *Star Trek* Fans
BIANCA SPRIGGS

72—81
Star Trek Fans as Parody: Fans Mocking Other Fans
PAUL BOOTH

82—91
Lieutenant Sulu's Facebook:
'Professor' Takei and the Social Networking Classroom
NATHAN THOMPSON AND KENNETH HUYNH

92—101
The Borg: Fan Pariah or Cultural Pillar?
CHARLES EVANS JONES, JR

102—104
Editor and Contributor Biographies

105
Image Credits

Acknowledgements

As individuals, I believe that in those moments when our faces are momentarily seen above the others in the crowd, it is because we stand on the shoulders of giants. One of those is Henry Jenkins, whose pioneering work in the area of fan studies paved the way for this collection and the chapters in it. Another is Gene Roddenberry, creator of *Star Trek* who, in the midst of frightening and uncertain times, glimpsed the future and saw hope for those of us who would inhabit it. On behalf of the authors whose work you are about to read, I humbly acknowledge our debt to them.

It has been my pleasure to work with a number of very talented individuals from Intellect in assembling this book. Worthy of particular mention is the series' editor, Gabriel Solomons, whose vision and assistance (and, above all, patience) in the creation of the *Fan Phenomena* series and this volume have contributed significantly to pushing back the knowledge frontiers in popular culture.

Finally, there are the authors of the chapters you are about to read: Elizabeth Thomas, Cait Coker, Mike Boynton, Kimberly Kulovitz, Paul Booth, Bianca Spriggs, Nathan Thompson, Kenneth Huynh, and Charles Evans Jones, Jr. Keep your eyes skinned for the names of these brilliant emerging scholars; you'll be seeing them again in the years to come.

This volume is dedicated to the memory of my friend Dean Davis, who loved *Star Trek*, and who has seen the Final Frontier.

Bruce E. Drushel, Editor

Introduction: The Exemplar of Fan Culture?
By Bruce E. Drushel

→ When Intellect announced its intent to publish a series of anthologies on the objects at the centre of many and varied fan cultures, it seemed quite natural that *Star Trek Fan Phenomenon* would be among the first. For much of what we know about contemporary fandom – its antecedent conditions, its contexts, its practices, its attractions, and its seeming inexhaustibility – comes from both scholarly and less rigorous examinations of *Star Trek* (in its various television, film, print, and online incarnations) and its legions of devotees.

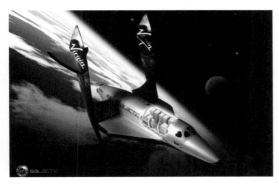

Fig. 1: The commercial spaceflight company Virgin Galactic christened its test vessel "Enterprise" after the starship in the Star Trek series.

The pioneers of Fan Phenomena

These devotees did not invent fandom, of course, though Camille Bacon-Smith (1992) contends that media fandom as it is now practised originated in *Star Trek* fandom. The term 'fan', according to Henry Jenkins's seminal work, *Textual Poachers* (1992), comes from 'fanatic' and has its roots in descriptions of the behaviour of unrestrained religious adherents. Later, the term was applied to followers of sports teams, and then to popular matinee actors and actresses. By the 1930s, science fiction's brand of fan culture already was well in place and given outlet in books and specialty magazines.

But *Star Trek*'s fans did raise their activities to an art form and their unconventional behaviours to a subject both worthy of study and difficult to ignore. Perhaps the most visible and infamous artefact of fan activity has been the convention or 'con'. As Bacon-Smith has observed, many fans first encounter their community through fan-run conventions, though only a small percentage of the attendees will belong to the fan clubs that promote them. 'Cons' include art shows, dealer rooms, lectures, and panel discussions with scientists or other guests. Attendance at local and regional 'cons' has dwindled over the decades from the thousands to the hundreds, perhaps because the Internet and social media allow for ongoing connections among fans. What remains are the commercial 'cons', which mostly sell merchandise and access to touring cast and crew members.

Writing in the *Village Voice* in 1997, Athima Chansanchai has noted that fans of *Star Trek* were among contributors to early fan magazines dedicated to them and that paperbacks also provided an outlet for them after the series was cancelled. Fans first began sharing their own stories with each other through the mail, according to Shoshanna Green, Cynthia Jenkins and Henry Jenkins (1998). But with the arrival of the World Wide Web and the consequent explosion of Internet use in the 1990s, *Star Trek* fans took full advantage of globe-shrinking technology. Chansanchai credits *Star Trek: Voyager* (*ST: VOY*, (1995-2001)) with being the first television series to have an extensive fan community in cyberspace. Two years after its debut in 1995, the series had over ninety websites dedicated to it, comprising well over a thousand fanfiction stories, as well as a 1,275-word encyclopedia of *Star Trek* jargon.

While they have embraced media technology for its aid in the formation and growth of their community, the relationship between *Star Trek* fans and the media frequently has been a contentious one. In her piece, 'A sociology of television fandom' (1998), Cheryl Harris writes that fans may be thought of as social groups that resist culture and insert their own meanings into cultural texts. From that, they derive pleasure from

Introduction: The Exemplar of Fan Culture?
By Bruce E. Drushel

their feelings of empowerment in the form of participation in popular culture. In other words, one purpose of discourse among fans is the making and sharing of meaning in the media texts they experience. The media – in this case the conglomerate Viacom/ Paramount whose intellectual property *Star Trek* is – facilitate this to a point, since loyal fans require less investment to maintain a level of consumption, and increased meaning-making is a sign of engagement and marketing success. But they draw the line at the point that activities become profitable for individual fans or otherwise threaten to damage the commercial value of the property. They also attempt to disempower fans by diverting their interests towards heavy spending on merchandise, such as DVDs and memorabilia from 'cons'.

The organization of this book
This collection examines what might be called 'The Mother of All Fandoms' from varied perspectives. The first part of the book, provides a history of *Star Trek* fan culture, including the impact upon fans of the theatrical 'reboot' of the franchise in 2009 and of the late Gene Roddenberry's unfulfilled promise to introduce gay and lesbian characters on *Star Trek: The Next Generation* (*ST: TNG*, 1987-1994). In the second part of the book, our authors explore efforts to move fan culture from its traditional venues of convention halls and magazines to entirely new spaces: the 'hyperpersonal' world of cyberspace and the culturally-elevating environment of a city park. In the third part of the book, we turn our attention to the image of the fan – first by allowing committed (but avowedly non-rabid) fans of the franchise to talk about themselves, how they are seen by themselves and others, and, of course, what they think of *Star Trek* – and then by examining the media's view of fan culture as expressed in a pair of films. In the final part of the book, our authors consider the potential for fan culture in teaching and learning, in particular how an iconic cast member uses his social capital among fans to shape the social landscape and what fan devotion to a villainous *Star Trek* race can tell us about political behaviour.

The truths about *Star Trek* fans
From the chapters that follow herein and from other writing about *Star Trek* fan culture that has been done elsewhere, three truths seem to be recurrent. First, *Star Trek* fans are a remarkably resilient breed. They have remained loyal to the franchise in spite of NBC's marooning of the original series (*ST: TOS*, 1966-1969) in a doomed time slot during its final season, the series' cancellation in 1969, the decade-long drought that followed without a single professionally-produced live-action story, the uneven quality of the eleven theatrical releases that followed, declining interest (and viewership) for successive television series spin-offs, and their continual berating and mimicry in the media and popular conversation, including a now-infamous 1986 sketch on *Saturday Night Live* (Lorne Michaels, NBC, 1975-Current) and films like *Galaxy Quest* (Dean

Parisot, 1999). They are the media-culture equivalent of baseball's Chicago Cubs fans, whom even decades of losing seasons cannot alienate.

Second, contrary to popular stereotyping, *Star Trek* fans are an incredibly diverse group. Though many fans are younger, particularly with the recent theatrical 'reboot' of the franchise and its recasting of the familiar characters from *ST: TOS* with actors and actresses young enough to be the grandchildren of the roles' originators, many also are older. *Star Trek: Enterprise* (*ST: ENT* (2001-2005), for example, had the distinction of having the oldest audience of any US prime-time broadcast network series during its five-year run – older even than the perpetually grey CBS newsmagazine *60 Minutes* (Don Hewitt, CBS, 1968-Current). Further contrary to the archetypal imagine of the nerdy young geek male, *Star Trek*'s fan base is made up of large numbers of both men and women, according to Henry Jenkins and Cheryl Harris, both of whom have written extensively about fandom. That women would be among the most persistent fans of the franchise is noteworthy, given its early confinement of female crew 'eye candy' roles or to short-term romantic interests more doomed than the archetypal 'red-shirted ensign' who seldom sees an episode's third commercial break. Devotees are straight and queer, despite producers' continued refusal to cast even one queer character. And even though other types of fandom are primarily white, people of colour figure prominently among *Star Trek* fans, as do Jews, Muslims and inhabitants of six continents.

Finally, far from being isolated and detached from society at large, *Star Trek* fans interact widely with and impact mainstream culture. Put succinctly, we are mindful of them and they matter. Apart from being exemplars to other fan groups, including those of sports teams, pop music performers, television series and video games, their commitment and persistence moves government agencies, media conglomerates, the scientific community, entrepreneurs and the popular imagination. As Henry Jenkins (1992) has observed, that construction of the *Star Trek* devotee differs markedly from their image in mainstream culture: as either dangerous psychopaths with no power over the subject of their obsession, star struck comic creatures or orgiastic groupies.

But in a 1997 article for *Science Fiction Studies*, Anne Cranny-Francis has described how fanfiction writers, inspired by *Star Trek*'s stories on television, in film and in books, in turn are read by the professional writers responsible for scripts of future episodes and films. The professional writers are loath to admit them as a source of inspiration, but there is evidence they are aware of what fans write. In some cases, the fans actually have become professional writers themselves. The influence on the media of fan writing is not limited to narrative efforts, but extends to advocacy as well. Prior to *Star Trek*, US television networks were notoriously unresponsive to mail from fans. Yet, in 1968, it was an orchestrated deluge of mail from *Star Trek* aficionados that saved the series from its first encounter with cancellation. A similar campaign prompted NASA to name its shuttle prototype *Enterprise*, honouring the franchise's iconic starship. A later shuttle mission bore the ashes of the franchise creator, Gene Roddenberry, the first time such

Introduction: The Exemplar of Fan Culture?
By Bruce E. Drushel

a service had been performed.

Physicists, many of whom credit their career choice at least in part to having watched a *Star Trek* series or film, frequently invoke *Star Trek* in discussions in the popular media of scientific developments and interests. One of them, Lawrence Krauss, whom his publisher calls a 'dedicated Trekker', even wrote *The Physics of* Star Trek (1995), as a testament to the science its producers got right … and wrong. Business entrepreneurs like PayPal's Elon Musk, Microsoft's Paul Allen, Amazon.com's Jeff Bezos and Virgin's Richard Branson have all invested millions that they've earned from their core businesses into private space travel ventures, inspired partly by boyhood fascination with space travel and, as articles in the *Daily Telegraph*, *Palm Beach News* and *Puget Sound Business Journal* attest, with *Star Trek*.

And to those who still would doubt the cultural impact of *Star Trek* fans: who among us can look at a mobile flip-phone, a tablet computer with applications capable of everything from mapping our location to monitoring our respiration, or a Taser and not think that somewhere a *Star Trek* fan with memories of communicators, tricorders and phasers had something to do with their design or function? ●

~~~~~~~~~~

## GO FURTHER

### Books

*The Physics of* Star Trek
Lawrence M. Krauss
(New York: HarperCollins, 1995)

*Enterprising Women: Television Fandom and the Creation of Popular Myth*
Camille Bacon-Smith
(Philadelphia, PA: University of Pennsylvania Press, 1992)

### Extracts/Essays/Articles

'Amazon strikes video deal with CBS; Bezos gets *Star Trek*'
Greg Lamm
*Puget Sound Business Journal*. 20 July 2011.

'Iconic *Star Wars*, *Star Trek* costumes, more from Paul Allen collection, at Norton Museum of Art'
Jan Sjostrom
*Palm Beach Daily News*. 6 July 2011.

'Branson's Enterprise prepares for final frontier'
Nick Allen
*Daily Telegraph*. 9 December 2009, p. 17.

'A sociology of television fandom'
Cheryl Harris
In Cheryl Harris and Alison Alexander (eds). *Theorizing Fandom: Fans, Subculture and Identity* (Cresskill, NJ: Hampton Press, 1998), pp. 41–54.

'Introduction'
Cheryl Harris
In Cheryl Harris and Alison Alexander (eds). *Theorizing Fandom: Fans, Subculture and Identity* (Cresskill, NJ: Hampton Press, 1998), pp. 3–8.

'Normal Female Interest in Men Bonking: Selections from *The Terra Nostra Underground* and *Strange Bedfellows*'
Shoshanna Green, Cynthia Jenkins and Henry Jenkins
In Cheryl Harris and Alison Alexander (eds). *Theorizing Fandom: Fans, Subculture and Identity* (Cresskill, NJ: Hampton Press, 1998), pp. 9–38.

'Now, Voyager'
Athima Chansanchai
*The Village Voice*. 9 September 1997, p. 37.

'Different identities, different voices: Possibilities and pleasures in some of Jean Lorrah's *Star Trek* novels'
Anne Cranny-Francis
In *Science Fiction Studies* 24: 2. 1997, pp. 245–55.

Chapter
1

# Live Long and Prosper: How Fans Made *Star Trek* a Cultural Phenomenon

Elizabeth Thomas

→ In April of 1964, Gene Roddenberry, former fighter pilot and Los Angeles police officer, embarked on a mission to capture the imaginations of television viewers. Ultimately, he did much more than that. He and a small band of creative souls harnessed the world's newest telecommunications medium to attract both the geek and non-geek, and brought millions of individuals together in a decades-long movement that has forever changed the meaning of 'fandom'.

In its infancy, Roddenberry's *Star Trek* was trapped in something of a time warp. Audiences at that time did not value the programming in sufficient numbers until after its cancellation. Its proper audience simply did not have time to find it before it was gone, but their need for it persisted. The need grew so strong that thousands of fans gathered together and fought for a TV series, and they did so long before the Internet or e-mail. They found one another. They met. They wrote millions of letters and they never stopped asking for new programming.

### The genesis of *Trek* fandom
Clearly, *Star Trek*'s five-year mission was never realized; the series was cancelled after three seasons. It actually was cancelled at the end of its second season, but according to the authors of Bantam Books' *Star Trek Lives!* (1975), intense pressure by fans convinced NBC executives to grant a one-year reprieve. Unfortunately, the ratings in that third season failed to climb and the show suffered its fate a year later, despite a renewed letter-writing campaign by avid fans.

Marketing personnel at the network complained to management that the series' cancellation was premature. New techniques for profiling demographics later demonstrated that *Star Trek*'s audience had been highly profitable for its advertisers. While this revelation came too late to resume production, *Star Trek* was far from over.

The original series (1966-1969) did not simply fade away like so many other failed shows. Its loyal fans lobbied incessantly for repeats of the original 79 episodes. The magic number to make an 'off-network' series marketable to mainstream television channels always had been (and still is) 100 episodes – a milestone *Star Trek* never hit. Much later, 80 episodes of classic *Trek* aired in syndication when NBC finally responded to constant prodding by fans and agreed to syndicate the original series despite its paucity of episodes.

### Like Tribbles, Trekkies multiply quickly
In 1972, after it had cancelled *Star Trek*, NBC admitted it had made a mistake. The confession can be attributed solely to the efforts of the show's fans – not its creator, the writers, cast members or Desilu studio executives. The fans never stopped writing letters to the network. They never stopped calling … and calling.

It took just under three years to convince NBC to syndicate reruns of the original series (which continue to air today, more than 46 years after the original show debuted). In 1972, Paramount also began to negotiate seriously with Roddenberry for a new live-action revival of the series, although it was many years before *Star Trek: The Next Generation* (*ST: TNG*, 1987-1994) would air.

Meanwhile, jubilation had started to spread among the show's fans. With the reruns now airing in syndication, the show's fan culture took on a life of its own far removed from Roddenberry's own efforts to revive *Star Trek*. The fans had found each other. Fans

Live Long and Prosper:
How Fans Made *Star Trek* a Cultural Phenomenon
Elizabeth Thomas

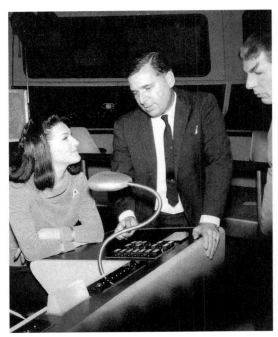

*Fig. 1: Actress Majel Barrett, Gene Roddenberry, and actor Leonard Nimoy in a photograph from the Star Trek pilot, 'The Cage.'*

like teenagers Phil Sneed and Cheri Daw, who got involved with *Trek* right up to the tips of their rubber Spock ears. In the span of just three months, the 16-year-old duo started the first 'fanzine', completed their own *Star Trek* novel, and started the first of many *Star Trek* fan clubs.

What was truly remarkable about these very young *Star Trek* fans was that they were not unique. *Star Trek* fans were not just teenagers. The younger fans were inextricably linked to tens of thousands of middle-aged housewives, married couples, labourers and professors. Sneed and Daw later founded Star Publishing, the first publishing company devoted entirely to *Star Trek* literature. In so doing they unleashed the creative forces of hundreds of fantasy writers who developed a multi-million dollar industry of *Star Trek* fiction.

Hundreds of *Star Trek* authors published with Star Publishing throughout the 1970s, while still more fans continued to build new relationships with *Star Trek* based on a later animated cartoon series and reruns of the original episodes. The momentum that had begun with a simple letter-writing campaign kept the series on the air for a third season in 1968, got it into syndication in 1971, and eventually would give it an entirely new life in films.

### Publishing proliferates and prospers

Publishing was at the centre of the fan phenomenon that propelled *Star Trek* throughout the 1970s. The first licensed books and comics appeared during the series' second season. In many ways, the publishing industry sparked the fan revolution that later served as a lifeline for every avid Trekkie. It harnessed their interest in the show and its characters, and kept them alive even when there was no starship *Enterprise* making the leap to light speed.

In 1968, the first non-fiction book on the series appeared, *The Making of the TV Series, Star Trek*, by Stephen E. Poe (writing as Stephen E. Whitfield). The author was employed by model maker AMT, known then for its plastic kits for assembling miniature *Star Trek* space vessels, communicators and weapons. Enthralled with the series from the first airing, Poe negotiated a deal with Desilu Studios and Gene Roddenberry to write *Star Trek*'s first authentic behind-the-scenes history. The first *Star Trek* novels also began to appear that year, published by Whitman Books. In 1970, Bantam Books published the first novel intended for adult audiences, *Spock Must Die!* written by well-known science fiction author James Blish. Blish also would adapt each episode of the original series for a twelve-volume collection of short stories published by Bantam.

Long before *Star Trek: The Motion Picture* (Robert Wise, 1979) ever hit the screen,

Bantam Books fulfilled fans' needs for visual and narrative material. It fed them dozens of 'Fotonovels' (adaptations of original episode scripts illustrated with actual photography from the series). Bantam's contributions also included thirteen original novels and two short story anthologies under the banner 'Star Trek: The New Voyages'. For the first time in history, fans would be paid to write about a show they loved. The anthologies allowed some fans to become professional authors, and some of them to become household names in the decades to follow.

### From concept to con

Science fiction conventions had been around for years before *Star Trek* was conceived, but they were never the same after *Trek* fans joined in. Initially, *Star Trek* fans were barely tolerated at traditional sci-fi events. Then, two early organizers, Elyse Pines and Joan Winston, decided to gather a couple hundred acolytes in one location and celebrate *Star Trek* far from the sneers and jeers of other sci-fi aficionados. What began as a meeting in one fan's living room grew into the convention or 'con' that changed fan meetings forever. The inaugural event took place at the Statler Hilton Hotel in Manhattan, 21–23 January 1972, and featured keynote speakers Gene Roddenberry and famed science fiction writer, Isaac Asimov.

At a pre-convention talk designed to measure fan enthusiasm, event organizers were completely overwhelmed when a room they rented to hold 300 people became jammed by 750 actual attendees. It soon became clear that the pent-up demand for *Star Trek* was huge. So was its first major event. The first *Star Trek* con received a front-page headline in the *New York Times*. In *Star Trek Lives!*, the loving tribute to fans and fandom by Joan Winston, Jacqueline Lichtenberg and Sondra Marshak, the authors report that both *TV Guide* and WABC requested entry to the first con and WCBS News later called expressing anger that it was not on the original guest list.

On Friday, 21 January 1972, more than 200 people stood in line for over six hours before the first-ever convention opened. By that Sunday afternoon, nearly 3,000 tickets had been sold, after which the committee simply started letting fans in free of charge. Once inside the event, awestruck fans were cooperative and courteous to one another, even friendly and grateful for the effort in organizing the con. But no one was more affected by the enthusiasm of the fans than Gene Roddenberry himself.

Roddenberry and his wife and *Star Trek* actress (portraying Nurse Christine Chapel) Majel Barrett attended the event and supplied what is now a well-known blooper reel, something that had not been seen from the TV industry before. Thousands in attendance were treated to the first public screening of the never-before-aired original *Star Trek* pilot, 'The Cage'. Even NASA got in on the act, supplying a gigantic replica of the Lunar Module for display in the con exhibit hall.

When the Roddenberrys first attempted to enter the exhibit area that Friday, a young volunteer stopped them at the door and asked to see their badges, explaining that only

Live Long and Prosper:
How Fans Made *Star Trek* a Cultural Phenomenon
Elizabeth Thomas

registered attendees and those affiliated with *Star Trek* were allowed to enter. Rodden-berry replied, 'Young man, I AM *Star Trek*,' and marched right by, according to con or-ganizer and author Winston.

Roddenberry was stunned by the turnout. He was overheard repeating throughout the day, 'I just can't believe it, all these great people coming here to honor *Star Trek*.' Then, the ABC and CBS television crews showed up and began filming. Chaos reigned. At one point, both Roddenberry and Asimov had to be secretly spirited away to private rooms for interviews, since the convention hall was over capacity and consumed in a joyous bedlam, wrote Winston.

### Infinite diversity in infinite combinations

The Roddenberrys were mobbed everywhere they went. Speeches were made and scientific talks presented. Finally, at one point during the convention, Roddenberry opened the floor to questions. 'What does the "T" in James T. Kirk stand for?' a fan shouted. The room was suddenly silent. The question had been hotly debated among fans for years and speculation was rife. The most popular theory was that the 'T' stood for 'Tomcat', which would have embodied Captain Kirk's reputation for being something of a Lothario. Roddenberry answered, 'It stands for Tiberius.' Until that moment, even William Shatner did not know that this was his character's middle name, according to author Richard Keller Simon in his 1999 book, *Trash Culture: Popular Culture and the Great Tradition*.

The first memberships to the official *Star Trek* Fan Club were sold at the groundbreak-ing 1972 Manhattan con. It was after that first wildly successful event that the previously underground *Star Trek* fan movement began drawing mainstream attention. Followed closely by intense coverage in *TV Guide*, the convention sparked growth of the first of-ficial *Star Trek* Club. Before 1972, there had been no single, unified organization. In the years that followed, membership grew to include millions all around the globe. The initial con would serve as a template for thousands of events over the next four-plus decades. The basic event format included trivia contests, exhibits, vendors with memorabilia for sale, artwork on display, autograph-signing sessions and a 'costume call'. The fans had set the wheels in motion for a phenomenon never before experienced in fan culture.

At the close of the initial con, the organizing committee was presented with a ban-ner made by attendees. It bore over 1,000 signatures and carried a simple message of thanks. To those committee members, it represented love. And love was what *Star Trek* conventions were made of; love ultimately was what *Star Trek* was all about – love of self and love of fellow man. *Star Trek* fans discovered that loving a show or an ideology was nothing to be ashamed of.

### Tribbles, Tricorders and TV icons

Creation Entertainment was founded in 1971 by Gary Berman and Adam Malin, two

teenage fans from New York. Today, Creation continues its 41-year tradition of produc-ing conventions for fans of multiple television and film texts with huge fan cultures. It has been producing *Star Trek* conventions for more than four decades in cities all over North America and Great Britain.

At the height of *Star Trek*'s new popularity in the early to mid-1990s, Creation was organizing 110 conventions a year, sometimes three in a single weekend. It built a li-censing history with Paramount and Viacom Consumer Products, and together, these companies sold hundreds of millions of dollars in official *Star Trek* merchandise. More recently, they began holding an annual 'Official *Star Trek* Convention', as a main event in Las Vegas. Fifteen thousand people bought tickets to the initial Las Vegas conven-tion in 2005. The convention should not be confused with '*Star Trek*: The Experience', a separate themed attraction at what was previously called the Las Vegas Hilton in Las Vegas, Nevada. The Vegas attraction and museum opened in January 1998 and closed after a decade in September 2008.

A 40th-anniversary convention was held in Las Vegas in August 2006. Vegas also was a stop on the international tour of the '40 Years of *Star Trek*: The Collection' exhibi-tion. In 2009, The History Channel produced a documentary, *Star Trek: Beyond the Fi-nal Frontier* (John Logsdon, 2007), which documented the overwhelming popularity of these conventions.

The official *Star Trek* website today is CBS Entertainment's startrek.com, although there are literally thousands of other *Star Trek* and *Trek*-related sites. TrekWeb.com also is popular, believed by many fans to be the more reliable or prestigious site because of its connection to Paramount Pictures, the production company that now owns all *Star Trek* properties.

**No end in sight**
In 1986, Roddenberry and a team of new producers finally succeeded in creating the much anticipated second *Star Trek* television series, set 100 years further in the future than the original. The original *Star Trek* was set 300 years in the future, in the year 2266; *ST: TNG* was set in 2364. The new embodiments of the *Star Trek* story enjoyed far greater commercial success than the original series. *ST: TNG* aired in first-run syndication on a loose confederation of US television stations and on channels around the world for seven full seasons, featuring an entirely new crew but exploring space with the same 'to boldly go where no one has gone before' mission aboard an updated starship *Enterprise*. Its popularity with viewers would spawn three additional series (*Star Trek: Deep Space Nine*, 1993-1999; *Star Trek: Voyager*, 1995-2001; and *Star Trek Enterprise*, 2001-2005), the last two of which would anchor the schedule of a brand new US broadcast network, UPN.

Fans have continued to clamour for more *Star Trek*, although it took the early success of science fiction films like *Star Wars* (George Lucas, 1977) and *Close En-counters of the Third Kind* (Steven Spielberg, 1977) in the late 1970s to finally con-

Live Long and Prosper:
How Fans Made *Star Trek* a Cultural Phenomenon
Elizabeth Thomas

vince executives at Paramount that there was enough interest to begin production of a film that could possibly be expanded into a franchise. When Paramount finally made its move in 1979, it was a wise one. *Star Trek: The Motion Picture* grossed $82 million, even though most critics and fans alike agreed it was not a stellar piece of film-making. Still, it spawned a continuing series of feature films, seven of which featured the cast of the original series. Following a 'reboot' of the cinematic franchise intended to boost increasingly lackluster box-office returns and draw younger fans to the base, Paramount is currently in production on the twelfth *Star Trek* feature film.

**Roddenberry and fans realized**
Across all the series and films, the stories of *Star Trek* stressed teamwork and cooperation, something that America was ready for in the 1960s and that it has yet to grow weary of. Though *Star Trek* was nominally international and intergalactic in its characters, the franchise ultimately celebrated America's presence in the universe. If the mainstream populace of the 1960s was simultaneously awed and frightened by science, in *Star Trek*, the benefits of technology were celebrated. That so many intelligent Americans are still devoted fans speaks strongly to an underlying belief in the application of science to achieve 'belongingness', at the apex of human needs. *Star Trek* fans, along with Gene Roddenberry, explored the classic oppositions between individual and society, reason and emotion, common sense and technology, humans and aliens, and all of these common struggles were consistently and triumphantly reconciled in the world of *Star Trek*.

On the sets of all his series and motion pictures and even in some fan circles, Roddenberry frequently was referred to as 'The Great Bird of the Galaxy'. In January 1975, as he contemplated the question, 'What is the measure of a *Star Trek* fan?' the Great Bird himself wrote:

Of thousands of them I have met over the years – people of widely varied ages, occupations and backgrounds – one unusual quality seems to have been shared by all [...] The typical *Star Trek* fan is invariably a remarkably gentle human being, gentle as in the lovely but too often archaic concept of gentleman and gentlewoman – the kind of gentleness which comes out of an affection for this universe in general and for life in particular. It is this capacity for affection which led *Star Trek* fans to approve and appreciate the view that humankind is not best characterized as evil – as the visionless would have one believe – but, rather, that its past has been a lusty infant's period of learning by trial and error [...] [the child] is moving toward a proud adulthood, of course. In time, perhaps even beyond that. The fans and I dream the same dreams about such things. That is our bond.

Though Roddenberry passed away on 24 October 1991 (during season five of *ST: TNG*), fans continue to cherish his ideals and *Star Trek*, and that shared vision of the fu-

ture – his and theirs – continues to evolve. The original five-year mission of the starship *Enterprise* has been extended, seemingly indefinitely, and transformed into a cultural phenomenon that continues to 'boldly go where no man (or fan) has gone before'. ●

## GO FURTHER

### Books

*Star Trek 365: The Original Series*
Paula M. Block with Terry J. Erdmann
(New York: Abrams Publishing, 2010)

*Inside* Trek: *My Secret Life with* Star Trek *Creator Gene Roddenberry*
Susan Sackett
(Tulsa, OK: Hawk Publishing Group, 2002)

*Trash Culture: Popular Culture and the Great Tradition*
Richard Keller Simon
(Berkeley, CA: University of California Press, 1999)

Star Trek *Chronology: The History of the Future*
Michael Okuda and Denise Okuda
(New York: Pocket Books, 1996)

Star Trek *Creator: A Complete Roddenberry Filmography Including All His* Star Trek *Episodes* David Alexander
(New York: Penguin Books, 1995)

*Gene Roddenberry: The Last Conversation*
Yvonne Fern
(Berkeley, CA: University of California Press, 1994)

*Gene Roddenberry: The Myth and the Man Behind* Star Trek
Joel Engel
(New York: Hyperion, 1994)

*The Making of the TV Series*, Star Trek: *The Behind-the-Scenes Story of the Most Popular Science Fiction Show Ever Made!*
Stephen E. Whitfield and Gene Roddenberry
(London: Titan Books, 1991)

**Live Long and Prosper:**
**How Fans Made *Star Trek* a Cultural Phenomenon**
Elizabeth Thomas

Star Trek *Lives!*
Jacqueline Lichtenburg, Sondra Marshak and Joan Winston
(New York: Bantam Books, 1975)

*Spock Must Die!*
James Blish
(New York, Bantam Books, 1970)

**Extracts/Essays/Articles**

'Utopian Enterprise: Articulating the meanings of *Star Trek*'s culture of consumption'
Robert V. Kozinets
In *Journal of Consumer Research*. 28: 1 (2001) 67-88.

**Online**

*Creation Entertainment*, http://www.creationent.com/company.htm

*The Official Star Trek Website*, http://www.startrek.com/

# THE NEEDS
# OF THE MANY
# OUTWEIGH
# THE NEEDS
# OF THE FEW.

**MR. SPOCK**
STAR TREK II: THE WRATH OF KHAN

Chapter
2

# Not Your Daddy's *Star Trek*: Rebooting a Franchise and Rewriting a Fandom

## Catherine Coker

→ On 18 January 2008, theatre audiences for *Cloverfield* (Reeves) watched a teaser trailer that combined footage of welders at work on the USS *Enterprise* with audio clips of John F. Kennedy's famous moon speech. As the strains of a well-known theme song swelled and Leonard Nimoy stated the iconic words: 'Space, the final frontier,' two words appeared on-screen: *Under Construction.*

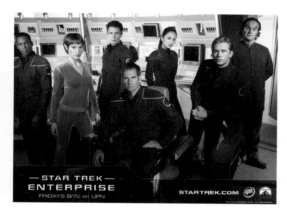

*Fig. 1: Enterprise (later Star Trek: Enterprise) was a Star Trek "prequel" and the last of the television series to date. Its last original episode aired in 2005. Image © Paramount Pictures.*

J. J. Abrams's *Star Trek* would not be released until May of 2009 and the highly secretive project made many fans nervous. Though an admitted 'fanboy', Abrams was best known for his mainstream television shows like *Alias* ( Abrams, ABC, 2001-2006) and *Lost* (Abrams, Lieber, and Lindelof, ABC, 2004-2010). How was he going to success-fully reinvigorate a franchise as old as *Star Trek*? Fifteen years of media saturation (between 1993 and 2001, at least three television series spin-offs were airing concurrently in addition to the biennial feature films and syndicated TV reruns) had overseen the fandom's decline in recent years, culminating in the abrupt cancellation of the fifth live action series, *Star Trek: Enterprise* (2001-2005), in 2005. When *Star Trek* (Abrams, 2009) (I shall refer to the 'reboot' as *Star Trek XI* hereafter, for clarity) debuted at a surprise screening in Austin, hours before the official release in Ja-pan in late April, initial word-of-mouth was positive. When it officially opened in the United States two weeks later, it was greeted as a certified hit, prompting satirical news-paper *The Onion* to comment in 2009, 'Star Trek fans are decrying the latest film in the long-running series as a fun and watchable action-packed thrill ride!' The theaters were full, often with repeat viewers, and its crossover success with general audiences meant that discussion of the film was not limited to the traditional cult fanbase.

Being a *Trek* fan since I was a small child, I sat in the audience on opening day, hesi-tant throughout the majority of the film. The people on-screen had the names and even some of the familiar tics of the characters I had known so well, but they were – differ-ent. An early scene of Starfleet Academy students panned widely across a sea of white faces, punctuated here and there by an exotic alien figure. *Star Trek* had always been an idealized future; its background in 1966 filled with more women and people of colour than will often be seen in contemporary programs today. Where *was* everyone? There were explosions and chases and fight scenes without pause; it resembled a video game more than the familiar science fiction parables of the past. What was I to make of this?

### Revitalizing a fandom
The film was promoted as 'Not Your Daddy's *Star Trek*' – emphasizing its distance from its source material as well as making a blunt appeal for a newer, younger audience. The film-makers and their marketing engines largely succeeded: a multitude of online com-munities and message boards began to appear to discuss the film, its actors, and to share fan works. Some web communities were created in direct response to the issues I was worried about, such as *Where No Woman*, a Livejournal community dedicated to 'Un-erasing the Women of *Star Trek*'. Others were created to celebrate or champion the

**Not Your Daddy's *Star Trek*:**
**Rebooting a Franchise and Rewriting a Fandom**
Catherine Coker

various factions within fandom, as with the 'Ship Wars' – a series of online 'events' to 'mock competitively' fan works devoted to various relationship pairings such as Kirk/Spock, Spock/Uhura, Kirk/McCoy, and so forth. Within a week of *Star Trek XI*'s release there were hundreds of such works, including fan art, icons, GIFs, vids and stories; within a month, there were thousands. Clearly fans both new and old were already invested in the fandom's newest iteration.

The fan works themselves often responded in two ways to the new film. Many drew from the decades of history available through the other franchise media, including the various series and secondary materials like the tie-in books. (In fact, it is through the tie-in novels that the names of several characters – Hikaru Sulu in *The Entropy Effect* [Vonda N. McIntyre, 1981] and Nyota Uhura in *Star Trek II Biographies* [William Rostler, 1982] were adopted for use on-screen.) Communities were instrumental in pointing new fans in the direction of resources that were as canonical as possible. Both official and unofficial resources work at maintaining the illusion that the world of *Star Trek* is coherent, with defined histories and cultures that apply to 'contemporary' politics that likewise lend motivation and backstory to each of the characters. In his 2003 article '"Carved from the Rock Experiences of Our Daily Lives": Reality and *Star Trek*'s Multiple Histories', Lincoln Geraghty notes that

[i]t is interesting to note that as an officially licensed publication the monthly *Star Trek* magazine helps to maintain the illusion of an accurate historical *Star Trek* timeline. There are often special articles highlighting the continuities and connections that *Star Trek*'s fictional events have with real life: these articles help to 'reinforce' [...] 'the show's status as a living, breathing, developing entity' and project an image of a coherent and unerringly comprehensible 'history' which real-time world events do not have.

The 2001–05 series *Enterprise* was haunted by the real world tragedy of 9/11 while its fictional world was preoccupied with the physical and emotional aftermaths of the Xindi attacks. *Star Trek XI* had a similar aesthetic, opening with the world-changing event of the *Kelvin* disaster (in which the time-travelling Nero and his compatriots destroy a science ship and kill Kirk's father) and making the Battle of Vulcan and then the Battle of Earth the centrepieces of the film. By rewriting and subverting the original 1966–69 series (hereafter *ST: TOS*) world from that of optimistic futurism into one preoccupied with loss, vengeance and the struggle to make amends, *Star Trek XI* privileges the contemporary over the historical.

In a similar fashion, much of *Star Trek XI* fandom is fascinated by the alternative possibilities of textual revisionism, particularly when it comes to creating fan works. For new fans less inclined to develop a familiarity with 'old *Trek*', writing fanfiction using the genre trope of the Alternate Universe (AU) story was and is overwhelmingly popular (see examples at http://swing-set13.Livejournal.com/40237.html). AU stories take place

in different settings both in the past (as varied as Ancient Rome, Renaissance Venice and the American West), present (the characters rewritten as actors, writers and even coffee shop baristas) and future (stories where the villain Nero's attack on Earth in the film's climax succeeded or never happened). Modern day AUs emphasize contemporary concerns as well, albeit transformed from the political to the personal.

For instance, in traditional *Star Trek* slash (male/male romantic pairings) fandom, particularly from *ST: TOS*, stories focused on soul-searching questions of identity and masculinity; rather than identifying as gay or homosexual or as part of a non-heteronormative community, Kirk and Spock were written as two men with a great encompassing love that just happened to be with someone of the same sex and which overpowered all previous identities. *Star Trek XI* slash takes a very different view of the characters, assuming a more consciously fluid assertion of sexual orientation in a future in which it is assumed everyone is bisexual. There are no compunctions about falling in love with a member of the same sex; all obstacles in relationships are externalized, such as rival love interests, cultural miscommunications or other events. As defined by P. J. Falzone writing in *Western Folklore* in 2005, 'Slash is rebellion and utopian rewriting, an attempt to liberate the characters through radical sexuality.' In a modern-day setting, slash stories transport the utopianism of future acceptance into contemporary norms, enacting not only successful romances but also a politicization of the text at a time when debates on the status of gay families is consistently in the public eye.

*ST: TOS* fanfiction was focused overwhelmingly on Kirk and Spock, and through K/S gave rise to the term of 'slashfiction', but *Star Trek XI* fandom has many more ''shipper'' factions – those groups of fans that actively champion certain relationship pairings between characters. Because the film itself made a romantic connection between Spock and Uhura and emphasized the intense friendship of Kirk and McCoy, these pairings make up the major groups. Smaller online communities also are dedicated to stories focused on Chekov/Sulu, Kirk/Sulu, Kirk/Pike and McCoy/Pike. Het (or heteronormative romance) is represented by pairings of any of the men – but predominantly Kirk or McCoy – with the new minor character of Gaila and McCoy/Chapel. There is also a significant femmeslash – slash pairings of women characters – a contingent that often is Gaila/Uhura, but also Chapel/Rand (about whom there were some stories written during the *ST: TOS* fandom days).

In the intervening decades since initial K/S, attitudes towards alternative sexualities obviously have changed drastically, but the truly remarkable thing is how the original text encompasses a similar change in attitudes. In *Star Trek XI*, after an irritated Uhura innocently states her surprise at Kirk's flirting since she thought that 'dumb hicks only had sex with farm animals', Kirk's smirking response is, 'Well. Not *only*.' Uhura's response – and that of the audience – is to laugh in appreciation. In Alan Dean Foster's film novelization, Kirk's sexual promiscuity again comes up as a point of contention, after which he concludes, 'they [the aliens he had slept with] were *all* humanoid – I think'. In other fran-

**Not Your Daddy's *Star Trek*:**
**Rebooting a Franchise and Rewriting a Fandom**
Catherine Coker

chise novels such as Rudy Josephs's *The Edge* (2010), sexual subtext between popular characters becomes less subtextual: the romance of Spock and Uhura, hinted at in *Star Trek XI* itself, is further explicated while the developing friendship of Kirk and McCoy takes on additional meaning:

She placed a hand on [McCoy's] arm, remembering back to what Spock had said about her flirting. She meant even less by it now, but she figured if she could use a bit of flirtation to her benefit, then so be it. But her touch went unnoticed. McCoy was too busy exchanging a suspicious glance with Kirk. Uhura was trying to find a way to ask about the eye contact, but Lynne beat her to it.

'What was that?' Lynne asked.

'What?' Kirk replied, throwing up his hands in mock confusion. If he ever wanted to make it in Starfleet, he was going to have to work on his innocence act. An enemy captain would notice that right away if they were ever in a showdown.

'I think she means that look you two shared,' Uhura said. 'And don't ask "what look," because it couldn't have been more obvious.'

'Can you blame me for looking at him?' McCoy joked. 'He's just so *dreamy*.'

Though at times *Star Trek* can be homosocial, with its focus on male friendships and relationships, to the point of heterophobia (few contemporary films have failed the Bechdel Test[1] as spectacularly as *XI*), the humour displayed in each of these scenes is at odds with the documented history of the official franchise's hostility to LGBT issues (see Chapter 3). This is a hopeful sign for long-time fans who are themselves looking for more acceptance from the world they always wished was real.

Less optimistic, however, was the 'Uhura RaceFail' debacle. 'RaceFail 2009' was a year-long crisis in fandom regarding race relations and depictions in science fiction generally and SF fandom in particular (see http://fanlore.org/wiki/RaceFail_'09 and http://www.fanhistory.com/wiki/Race_Fail_2009). The Uhura RaceFail came about both as an extension of the greater RaceFail and consisted of the backlash against the new Uhura, who was Kirk's crush and Spock's love interest. Fans complained that the character was too angry and bitchy and that she 'slept her way to the top' through Spock rather than earning her place on the bridge. Some were offended that it was a black woman contrasted with the two white leads; others felt that her place in the story interrupted the canonical K/S subtext. At any rate, the blog posts, discussion boards, fan secret memes (written or graphical representations of anonymous 'secrets') and other works demonstrated both the discomforting message of hate at odds with the typical display of affirmation more common to fandom. As the summer continued, tensions continued to mount, until both sides flagged in exhaustion. Months later, the 'haters' moved on to their next targets, leaving the majority of fandom without further crises or incidents.

Fig. 2: Director J.J. Abrams was recruited to direct a "re-boot" of the Star Trek cinematic franchise. Image © Paramount Pictures.

### Revitalizing a franchise

The online omnipresence of fan works also acted as a balm during the wait for the next film. During the decade that *ST: TOS* reruns were the only screen franchise presence, publishers began a series of volumes that collected fan writings, adaptations of episodes aired and new novels; dozens of such books were printed and reprinted. Official materials between the 'reboot films' have been slower to come. The initial spate of 'Starfleet Academy' volumes, describing the fictional events that took place off-screen during *Star Trek XI*, were delayed until late 2010; rumours alleged that some material or plots in the book related too closely to what would be seen in the then in-process script for *Star Trek XII*. When the books were released, the first two volumes appeared out of order: the first volume, chronologically – *The Edge* – was published after *The Delta Anomaly* (Rick Barba, 2010), while the third in the series, *The Gemini Agent* (Rick Barba, 2011), was published several months later; over a year lapsed then between that book and the fourth, *The Assassination Game* (Alan Gratz, 2012). While the ordering of tie-ins is typically of little consequence to the publisher or the readers, in the case of this series there are ongoing relationship arcs that progress from volume to volume. These include the developing friendship of Kirk and McCoy, the blossoming romance between Spock and Uhura, and the re-introduction or origin stories of other characters such as Chekov. The series also distinguishes itself as being written/marketed explicitly for (young) teens; to date there are no 'adult' volumes in the *Star Trek XI* universe.

In September 2011, IDW Publishing began to release *Star Trek* as a monthly comic book title. The stories were forthrightly created to bridge the gap between *Star Trek XI* and the forthcoming *Star Trek XII*; writers have stated that the series contains hints and clues about the plot of *Star Trek XII*, creating a sort of game for impatient readers. The first six issues adapted classic episodes ('Where No Man Has Gone Before' [Episode 1, Season 1], 'The Galileo Seven' [Episode 13, Season 1], and 'Operation Annihilate' [Episode 29, Season 1]) into the new universe. The April 2012 issue was the first to tell a completely original story, 'Vulcan's Vengeance', in which the governmental fallout depicted in *Star Trek XI* is seen for the first time in terms of the Federation's politics with the Romulan Star Empire. Subsequent issues combined both new story arcs with retellings and retcons (the act of altering previously established facts, known as retroactive continuity) to introduce additional information about the changing world of the characters.

**Not Your Daddy's *Star Trek*:**
**Rebooting a Franchise and Rewriting a Fandom**
Catherine Coker

All of this material has yet to be integrated into fandom's own work thus far; the general response seems to be: 'this is interesting but what we create ourselves is better.' The inexperience of the new writers of all of the official works is clear both in terms of characterization and plot construction, which contrasts powerfully with the franchise's history of usually publishing known science fiction authors (e.g. Vonda McIntyre and Joe Haldeman) or skilled writers who specialize in media tie-ins (e.g. Peter David, Margaret Wander Bonanno). This may well prove problematic in the long-term, though the full results of these franchise efforts have yet to be seen.

### The next movie is not *Star Trek 2*

The great part about being a *Star Trek* fan in 2012 is that *Star Trek XI* was a very popular mainstream film; a stray reference to looking forward to the next film is not greeted with an eye roll but often with a sympathetic nod. That said, there is a propensity, particularly in mainstream media, to refer to the forthcoming film as '*Star Trek 2*' – completely overlooking or ignoring that that film already exists and is called *The Wrath of Khan* (Meyer, 1982). Though perhaps pedantic, it is worth reiterating that the 'reboot' is in fact not a true 'reboot' since the characters and world portrayed are still part of *ST: TOS*. Everything that happened in the other series also happened in the reboot, but thanks to the disjunction/plot device of time travel, the 'current events' portrayed are different than they were in the initial timeline – hence the concurrent presence of both the aged 'Spock Prime' (Leonard Nimoy, reprising his role of nearly fifty years) and his younger counterpart.

Walking out of the theatre after seeing the new *Star Trek* for the first time, I wanted more – something I had unfortunately not experienced in a long time. Like many others, I returned to *ST: TOS* to re-watch episodes I hadn't seen in years, but more than that, I also had multiple opportunities to introduce the series to new fans who were unfamiliar with it. Other fans had similar experiences and I have to think that it was a not unusual occurrence at the time since, after all, our largely media-on-demand culture has kept the other series on shelves rather than in syndication on commonly accessible stations. For the first time in over a decade, at least, it was possible to introduce someone to the series as a complete neophyte. I have to think that the experience is not unlike what *ST: TOS* fans experienced in the 1970s, thus – almost literally – bringing fandom full circle. ●

## GO FURTHER

### Books

*The Assassination Game*
Alan Gratz
(New York: Simon Spotlight [Pocket Books], 2012)

*The Gemini Agent*
Rick Barba
(New York: Simon Spotlight [Pocket Books], 2011)

*The Delta Anomaly*
Rick Barba
(New York: Simon Spotlight [Pocket Books], 2010)

*The Edge*
Rudy Josephs
(New York: Simon Spotlight [Pocket Books], 2010)

*Star Trek*
Alan Dean Foster
(New York: Simon & Schuster, 2009)

Star Trek II *Biographies*
William Rostler
(New York: Pocket Books, 1982)

*The Entropy Effect*
Vonda N. McIntyre
(New York: Pocket Books, 1981)

### Extracts/Essays/Articles

'The Final Frontier is Queer: Aberancy, Archetype and Audience Generated Folklore in K/S Slashfiction'
P. J. Falzone
In *Western Folklore*. 64: 3/4 (2005), pp. 243–61.

**Not Your Daddy's *Star Trek*:**
**Rebooting a Franchise and Rewriting a Fandom**
Catherine Coker

'"Carved from the Rock Experiences of Our Daily Lives": Reality and *Star Trek*'s
Multiple Histories'
Lincoln Geraghty
In *European Journal of American Culture*. 21: 3 (2003), pp. 160–76.

'Out of the Closet and Into the Universe: Queers and *Star Trek*'
Henry Jenkins.
In John Tulloch and Henry Jenkins (eds). *Science Fiction Audiences: Doctor Who, Star Trek, and Their Fans* (New York: Routledge, 1995) pp. 237–65.

**Online**

'Racefail '09', 1 March 2012, http://fanlore.org/wiki/RaceFail_'09

'RaceFail 2009'
*Fanhistory.com*. 30 November 2009, http://www.fanhistory.com/wiki/Race_Fail_2009

'Trekkies Bash New Film as "Fun, Watchable"'
*The Onion*. 4 May 2009, http://www.theonion.com/video/trekkies-bash-new-star-trek-film-as-fun-watchable,14333/

'*Star Trek* Teaser Trailer and Review'
Anthony Pascale
*TrekMovie.com*. 18 January 2008, http://trekmovie.com/2008/01/18/review-star-trek-teaser-trailer/

'The Epic Kirk/McCoy AU Master List'
Swing_set13
*LiveJournal*, July 3, 2010. http://swing-set13.Livejournal.com/40237.html

*Where No Woman*, http://where-no-woman.livejournal.com/

**Note**
**(Endnotes)**
1 The Bechdel Test comes from the work of cartoonist Alison Bechdel; to pass the test, two women must have at least one conversation that is not about men. *IX* fails the test because there is only one scene in which two women talk – one of them being in underwear as she hides Kirk under her bed, to whom the conversation quickly steers.

# FATE PROTECTS FOOLS, LITTLE CHILDREN, AND SHIPS NAMED ENTERPRISE.

**COMMANDER WILLIAM RIKER**
STAR TREK: THE NEXT GENERATION

# Chapter 3

## A Utopia Denied: *Star Trek* and its Queer Fans

Bruce E. Drushel

→ For its queer fans, the *Star Trek* franchise always has been something of a paradox. On the one hand, its various television series and cinematic releases have depicted utopian ideals of peaceful coexistence; tolerance of differences in race, ethnicity and gender; and friendships and even romantic relationships that transcended traditional boundaries of identity. On the other hand, insiders have described the work environment behind the scenes as excessively gendered, heterosexist, and resistant to social change that goes beyond the aspirations of the 1960s culture that spawned it. On the one hand, a few of its cast and crew have openly identified themselves as sexual minorities, most famously actor George Takei. On the other hand, queer fans and other queer activists have continually been thwarted in their efforts to see identifiable sexual minorities as regular characters in the *Star Trek* universe.

Fig. 1: David Gerrold (seen here in a 2012 interview) wrote the iconic 'Trouble with the Tribbles' episode of Star Trek. Image © Paramount Pictures.

In general, while they have not been completely dismissive of its lesbian, gay, bisexual, transgender and queer (LGBTQ) fans, the managers of the franchise within Paramount Pictures have done little to embrace them and in fact seem to prefer to keep them at arm's length.

This chapter examines the complex and frequently contentious relationship between *Star Trek*'s producers and its queer fans, including the latter's efforts at organization and advocacy for the representation of queerness in the *Star Trek* canon, and the relationship between the franchise's broader fan base and the self-disclosures of its real-life queer icons.

### Endings and beginnings

To the series' many LGBTQ fans, the demise of the original series (*ST: TOS*, 1966-1969) in 1969 was as ironic as it was untimely, coming as it did just three weeks before the riots outside the Stonewall Inn in Greenwich Village heralded the start of the modern lesbian and gay rights movement. At the core of the irony was the fact that the series, which had been progressive in its treatment of Cold War paranoia and racism and which inhabited a seemingly utopian universe in which poverty had been eradicated and science promised solutions to what social problems still remained, would not admit that LGBTQ people existed, let alone allow them to serve humanity on its final frontier.

In 1986, following a rebirth of the franchise in the form of several feature films and rumours of a sequel for television (*Star Trek: The Next Generation*, hereafter *ST: TNG*, 1987-1994), lesbian and gay fans of *Star Trek* began forming The Gaylactic Network, a group that would eventually grow to eight chapters and 500 members. Depending upon the account upon which one relies, that of Billie Aul and Brian Frank in *Foundation* (2012) or of Mark Altman in *Cinefantastique* (1992), members of the group confronted *Star Trek* creator Gene Roddenberry and writer David Gerrold at a fan convention either in 1986 or 1987 and pressed for the inclusion of lesbian and gay characters in the sequel. Gerrold recalled Roddenberry telling the group, 'You're probably right. Sooner or later we'll have to address the issue and I'll have to give serious thought to it.' According to

A Utopia Denied: *Star Trek* and its Queer Fans
Bruce E. Drushel

Joe Clark of the LGBT newsmagazine *Advocate* in 1991, Franklin Hummel, the group's leader, would later complain that he and others had written follow-up letters to Roddenberry, to no avail.

### 'Blood and Fire' and failure

By Mark Altman's account, Roddenberry actually did raise the issue of a gay character in *ST: TNG* at a staff meeting in late 1987, early in the series' first season. Producer Robert Justman reportedly responded with a homophobic slur, but producer Herbert Wright was supportive and offered to collaborate with Gerrold on a script. The plot would be an AIDS allegory intended in part as a tribute to Mike Minor, a member of the production staff of Star *Trek II: The Wrath of Khan* (Nicholas Meyer, 1982) who was too sick to work on the series and who later would die from AIDS complications.

'Blood and Fire' concerned an encounter by the crew of the starship Enterprise with the Copernicus, a vessel infested with Regulian Bloodworms engineered to carry a deadly plague. Starfleet had issued standing orders to not attempt rescue of an infected ship, but instead to destroy it. Captain Picard, upon learning some of the crew had survived, determined to disobey the order, proclaimed, 'We're not throwing away half the human race because the other half is scared.' Kathleen Toth, writing in 1992 in the *Doctor Who Bulletin*, says the episode, which was to be among the sequel's first, also featured a gay male couple – Eakins, the security officer, and Freeman, a medic – who had been together two years. Freeman eventually would sacrifice himself to save the away team.

Reactions to the script from the production staff were mixed. Some staff memos criticized the homosexuality of the characters. Others praised it as a strong script. According to Mark Altman, Executive Producer Rick Berman said the episode couldn't run in markets that had scheduled the series in the afternoon. Though he had told gay fans at the convention otherwise, Roddenberry reportedly did not want an episode with gays as a primary focus since, according to Toth's account, sexuality would not be controversial in the 24th century. Gerrold has been quoted widely as saying he was ordered to remove the characters from the episode entirely and that he attempted several rewrites before abandoning it entirely. When word of the abandoned episode surfaced several years later, it became a cause célèbre among gay and lesbian fans, who assumed homophobia was the reason. According to *Advocate*'s Clark, they berated Roddenberry at conventions for years. The *Baltimore Sun* reported in 2003 that Gerrold auctioned copies of the script on eBay to counter rumours that the script was poor and that he had been fired.

The closest, in fact, that *ST: TNG* would come to representing any sort of same gender pairing was a pair of episodes in its fourth and fifth seasons. In Season 4, Episode 23, 'The Host', the ship's chief medical officer, Dr Beverly Crusher, fell in love with a symbiont, a being who lives in the body of human host, and communicates through him. When

the male host died and the symbiont was transplanted, Crusher was confronted with the prospect of continuing the relationship with its new female host, which she rejected. According to Clark, The Gaylactic Network's Hummel found the plot twist troubling, since the audience was left wondering whether Crusher's uneasiness was the result of the rapidity of the changes she was being asked to accept or the fact that she would have been in a same-sex relationship.

In Season 5's Episode 17, 'The Outcast', First Officer William Riker fell in love with Soren, a pilot from the J'naii species. The J'naii have only one gender and reproduce asexually. Her tryst with a male violated J'naii custom and Soren was threatened with psychotropic drug treatments to 'cure' her behavioural abnormality. The episode was broadly interpreted as an allegory for LGBTQ persecution. Critic Matt Roush, writing in 1992 in *USA Today*, argued that its broader attack on sexual intolerance made a greater impact on viewers than showing two male crewmembers holding hands as a condescending nod to 'gay activists' would have. Many of those activists disagreed.

**Return of the Gaylaxians**
As a 1991 article in *Maclean's* noted, 'The Outcast' was produced against the backdrop of renewed pressure by the Gaylactic Network. Frustrated by what they perceived as a lack of response to years of lobbying Roddenberry, and angered by revelations of the handling of the 'Blood and Fire' script, the Gaylactic Network staged a letter-writing campaign in May 1991 supporting the inclusion of gay and lesbian characters in the show. According to the Network's Franklin Hummel, the group believed the series likely would last at most two more seasons and that time was running out. Accounts in both *Cinefantastique* and *Foundation* claim *Star Trek* producers received more letters as a result of the campaign than they had on any other topic in the history of the franchise.

Initially, the flood of mail met with a stock response, summarized in a prepared statement from Roddenberry to *Advocate* (1991):

I've never found it necessary to do a special homosexual-theme story, because people, in the timeline of *The Next Generation*, the 24th century, will not be labeled. I've always said that when a good script comes along, of course, we'll consider it.

By July 1991, it became apparent the issue would not go away and, in another statement to *Advocate* widely reported elsewhere, Roddenberry appeared to change course: 'In the fifth season of *Star Trek: TNG*, viewers will see more of shipboard life in some episodes which will, among other things, include gay crew members in day-to-day circumstances.'

Sadly, Roddenberry died in November 1991, leaving his promise of queer representation on *ST: TNG* unfulfilled.

A Utopia Denied: *Star Trek* and its Queer Fans
Bruce E. Drushel

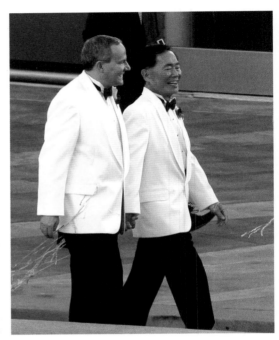

*Fig. 2: George Takei and longtime partner Brad Altman wed in California soon after marriage equality was legalized. Image © JustJared.com.*

## A 'Stigma' as postscript

Nearly sixteen years after 'Blood and Fire' first was proposed, *Star Trek*'s producers eventually did air an AIDS allegory. 'Stigma' was broadcast in February 2003, in the second season of *Star Trek: Enterprise* (*ST: ENT*, 2001-2005), the franchise's most recent (and least successful) television series. The plot concerned the revelation that T'Pol, the Vulcan science officer, had an incurable disease contracted from unwillingly engaging in telepathic mind-melds, which were stigmatized by Vulcan society along with those who engaged in them. Vulcan doctors refused her treatment.

David Gerrold, who had written 'Blood and Fire', approved of 'Stigma' but, according to John Coffren of *The Baltimore Sun* (2003), believed *Star Trek* could have made a greater impact in 1987 when the stigmatization was greater, no treatments were available, and blood shortages exacerbated by AIDS hysteria were critical. Writing in the *Boston Herald* in 2003, John Ruch was more critical of the episode. Just as the original *Star Trek* addressed race by showing people of various races and addressed war by showing war, he argued, the series should have addressed gays and AIDS directly rather than through allegory.

## Real people, real queer

If queer fans were frustrated by the apparent straightness of *Star Trek*'s fictional universe, they could be buoyed by a series of personal revelations by players in the franchise's real universe. The first was Gerrold, who had attained something close to *wunderkind* status during the run of the original series when, fresh out of college, he wrote the much-beloved 'The Trouble with Tribbles' episode (Episode 15, Season 2). Many of Gerrold's works outside of *Star Trek* are suffused with a queer sensibility including his novel *Martian Child* (2007) which, as Greg Herren noted in his review in *Lambda Book Report* (2002), actually is a chronicle of his efforts as a gay man to adopt a special needs child. Though his disappointment at Roddenberry's lack of support for 'Blood and Fire' led to his alienation from the franchise for some years, his popularity as an interview subject in fanzines and as a featured attraction at science fiction conventions never waned.

As significant as Gerrold was to the *Star Trek* franchise behind the scenes, his name recognition beyond core fans was limited. Not surprisingly, then, the decision by veteran cast member George Takei (Lieutenant Hikaru Sulu) to 'come out' in an interview with *Frontiers*, a Los Angeles LGBTQ weekly newspaper, in 2005 attracted far greater attention. The move turned out to be a boon for Takei's career, which had slowed since

his last *Star Trek* film appearance in 1991. He soon found himself as a frequent guest on Howard Stern's syndicated radio program, which, as the *Washington Blade*'s Katherine Volin (2008) has observed, helped both men: it gave Stern a popular foil with whom to banter and it gave Takei exposure to a new audience. He has parlayed his renewed visibility into an extensive series of public appearances and into a social media presence as a spokesperson for the 'It Gets Better Campaign' for queer youth and other LGBTQ causes. He told *Advocate* that the fan response to his coming-out had been overwhelmingly positive. Fans no doubt also were pleased by his 2008 wedding in which, according to the *Windy City Times*, fellow cast members Walter Koenig (Ensign Pavel Chekov) and Nichelle Nichols (Lieutenant Nyota Uhura) were best man and best lady, respectively.

While Takei chose to make his public disclosure late in life, a more recent cast member made his at the age of 34. Zachary Quinto, who played Spock in the 2009 cinematic reboot of the franchise, had refused to discuss his sexuality in a 2010 *New York Times* interview. Rumours of his queerness had been fuelled by his history of playing gay characters and of supporting LGBTQ causes. Almost a year to the day later, amid rumours linking him romantically with openly-gay *Glee* (Ryan Murphy, Brad Falchuk, and Ian Brennan, FOX, 2009-Current) actor Jonathan Groff, he abruptly came out in a 2011 article in *New York Magazine*. In a follow-up interview in the gay publication *Bay Windows* (2011), Quinto admitted his career likely would unfold differently after his admission, but said he was grateful for the outpouring of fan support.

### Queer readings: Garak, Q, Quark and Fajo

Film historian Vito Russo contends that lesbian and gay audiences deprived of representations of themselves and their communities in media texts frequently are able to make queer readings of otherwise heterosexual characters and situations, and so it has been with the series in the *Star Trek* franchise. *ST: TNG*'s recurring character Q was a frequent subject of such readings. Q was a non-corporeal (and therefore, one would assume, asexual) being who took the form of a human male in his frequent visits to the *Enterprise*. His obsessive interest in, first, Picard and, later, Riker, together with his penchant for mischievous games with which he would first imperil them and then rescue them in many respects resembled a courtship ritual. Patrick Stewart, who played Captain Jean-Luc Picard, revealed in a 1995 interview with Donna Minkowitz in *The Advocate* that he always regarded Q as gay.

In *ST: TNG*'s 'The Most Toys' episode (Episode 22, Season 3), the male android crewman Data was kidnapped by Kivas Fajo, a collector of rare objects, and forced to change from his uniform into alternative clothing. When Data resisted, Fajo, who was represented as both unctuous and unscrupulous, told him, 'Personally, I'd be delighted to see you go around naked. I assume you have no modesty.' Whether the statement reflected voyeuristic intent or the preoccupation of a collector with his new possession was left unanswered.

**A Utopia Denied: *Star Trek* and its Queer Fans**
Bruce E. Drushel

Texts of the franchise's third live-action series, *Deep Space Nine* (*ST: DS9*, 1993-1999), were particularly accommodating of queer readings. In the series' second episode, the young and handsome Dr Bashir met Garak, a lonely exiled Cardassian tailor. The portrayal of Garak was campy, complete with broad gestures, double entendres, witty remarks, and the desire to measure Bashir for a suit. As Billie Aul and Brian Frank have observed of Garak, 'He was, in fact, acting like a gay man – a stereotypical, pre-Stonewall, closeted gay man, but a gay man nonetheless.' Efforts by a straight fan to lobby producers into making Garak overtly gay failed. Garak instead ultimately was paired with a Caradassian female and Bashir befriended engineer Miles O'Brien, who was married and had a child, ensuring his heterosexual credentials.

Two episodes of *ST: DS9* featured cross-dressing. In 'Profit and Lace' (Episode 23, Season 6), Ferengi bar-owner Quark temporarily was transformed into a female to impersonate his mother, largely for comedic effect. In 'Rules of Acquisition' (Episode 7, Season 2), a Ferengi female, Pel, dressed as a man to take part in profit-making ventures, reserved in her highly misogynistic culture for males. When Pel fell in love with Quark, homosexual panic set in; he denied being kissed by her and refused to talk about it.

Two species introduced in the series, Changelings and Trill, presented opportunities for exploration of same-sex relationships that went largely unexploited. Changelings had the ability to take on the form of whatever object they chose, and they appeared to lack innate gender, though they experienced pleasure when they were joined, either with one or many others of their kind. Trill had the ability to host symbionts, wise and long-lived parasitic creatures whose personalities and experiences became part of the Trill's personality. Reminiscent of the plot of *ST: TNG*'s 'The Host', 'Rejoined' (Episode 6, Season 4) concerned the relationship between female Trill crewman Jadzia Dax and another female Trill who hosted a symbiont once married to Dax's symbiont. While there was an expression of what appeared to be same-sex desire between two women, it was framed in terms of the apparently heterosexual relationship between the symbionts' former hosts and failed to advance beyond handholding and a hug because of a Trill cultural taboo on reprising relationships between rejoined symbionts.

Several *ST: DS9* episodes concerned intersections with an 'alternative' universe in which the series characters existed in other roles and with distinctly different personalities. A mirror-version of first officer Lieutenant Kira was played as a predatory 'vamp' with omnivorous sexual appetites. But it was made clear that viewers could expect such behaviours only in the alternative universe, and the regular-universe Kira remained both unattached and heterosexual.

Two subsequent series, *Star Trek: Voyager* (*ST: VOY*, 1995-2001) and *ST: ENT* were largely devoid of such plotlines and less accommodating even of queer readings, in spite of the dominant role of female characters in *ST: VOY* and the almost exclusively male cast of *ST: ENT*. The franchise's eleven feature films, likewise, have lacked queer characters and themes. According to the Gay Lesbian Alliance Against Defamation, a published

report that a new crew character in the eighth film, *Star Trek: First Contact* (Jonathan Frakes, 1996), would be identifiably gay was refuted by Executive Producer Rick Berman.

### Homophobia, or homophobia-phobia?

The failure of *Star Trek*'s producers to include even one recurring LGBTQ character, or even one identified as queer by his or her alien culture, in the years since *ST:TNG* debuted is conspicuous, when one considers both the social progressiveness of the franchise and the number of leading, supporting and recurring lesbian and gay characters to appear in other series during the same period. Given the constant pressure exerted by activists and proposals like *ST: TNG*'s 'Blood and Fire' and *First Contact*'s Lieutenant Hawk, lack of awareness and lack of ideas for vehicles for the introduction of gay characters can be ruled out. That seems to leave heterosexism or homophobia on the part of *Star Trek*'s producers or their fear of heterosexism or homophobia on the part of audiences and advertisers as the most likely explanations. If homophobia on the part of the producers is the case, it represents a conspicuous departure from a key tenet of the franchise ideology: that the future is a better place free of petty bigotries. If instead the producers underestimate the progressiveness of the audience, it suggests they are out of touch with the core of that audience – the fans who have supported the show with little question from as far back as 1966.

Either way, as this review of the handling of the representation of queerness by the *Star Trek* franchise suggests, while queer readings may be applied to the relationships between Q and Picard in *ST: TNG* and between Garak and Bashir in *ST: DS9*, while homosexual behaviour may take place in an alternative (and clearly morally-inferior) reality in *ST: DS9*, and while gender nonconformity and AIDS may be treated by allegory in *ST: TNG* and *ST: ENT*, respectively, self-identified gay characters are absent and the producers have failed to provide a satisfactory explanation. Even the franchise's alien races generally are represented as having gender roles and sexualities corresponding to the mainstream of Earth-bound cultures in the twentieth century. And as Robin Roberts has noted in a chapter of the anthology *Fantasy Girls* (2000), since we have yet to encounter aliens outside of works of popular culture, *Star Trek*'s very traditional aliens must be seen as ciphers for humanity, and as a very limited view of humanity at that. ●

### GO FURTHER

#### Books

*The Celluloid Closet* (rev. edn)
Vito Russo
(New York: Harper Collins, 1987)

## A Utopia Denied: *Star Trek* and its Queer Fans
Bruce E. Drushel

### Extracts/Essays/Articles

'Quinto describes feeling grateful since coming out'
Alicia Rancilio
*Bay Windows*. 29: 45 (2011), p. 1.

'What's up, Spock?'
Benjamin Wallace
*New York Magazine*. 16 October 2011, p. 66.

'Career zigzag, changing coasts and galaxies'
David Rooney
*New York Times*. 24 October 2010, p. AR-6.

'George Takei weds longtime love'
*Windy City Times*. 17 September 2008, p.26.

'Sulu style'
Katherine Volin
Washington Blade. 11 January 2008.

'Stern's new gay sidekick'
*Advocate*. 14 February 2006, p. 22

'Short answers: George Takei'
Bruce C. Steele
*Advocate*. 6 December 2005, p. 26

'Time to add his political voice: George Takei's public acknowledgment that he is gay is connected to a belief in speaking out about initiatives that would limit gay rights'
Lynn Smith
*Los Angeles Times*. 4 November 2005, pp. E-33.

'AIDS allegory raises awareness on *Enterprise*'
John Coffren
*Baltimore Sun*. 5 February 2003, p. 1-E.

'*Trek*'s AIDS episode not so bold'
John Ruch
*Boston Herald*. 5 February 2003, p. 51.

'*Enterprise* explores AIDS-like story line'
William Keck
*USA Today*. 6 December 2002, p. 1-E.

'Parents are from Venus'
Greg Herren
*Lambda Book Report*. 11: 2 (September 2002), pp.16

'Prisoners of dogma and prejudice: Why there are no G/L/B/T characters in
*Star Trek: Deep Space Nine*'
Billie Aul and Brian Frank
*Foundation*. 86 (Autumn 2002), pp. 51-64.

'Science, race, and gender in *Star Trek: Voyager*'
Robin Roberts
In Elyce Rae Helford (ed.). *Fantasy Girls: Gender in the New Universe of Science
Fiction & Fantasy Television* (Lanham, MD: Rowman & Littlefield Publishers, 2000),
pp. 203-21.

'A new *Enterprise*'
Donna Minkowitz
*Advocate*. 22 August 1995, pp. 72-73.

'Blood and fire: the past is prologue'
Kathleen Toth
In *Doctor Who Bulletin (DWB)*. 107 (November 1992), p. 21.

'Tackling Gay Rights'
Mark A. Altman
In *Cinefantastique*. 23: 2/3 (1992), pp. 71-74.

'*Star Trek* focuses on sexuality'
Matt Roush
*USA Today*. 18 March 1992, p. 3-D.

'*Star Trek: The Next Generation* – Queer characters join the *Enterprise* crew'
Joe Clark
*Advocate*. 27 August 1991.

**A Utopia Denied:** *Star Trek* **and its Queer Fans**
Bruce E. Drushel

'Where no man has gone before'
*Maclean's.* 22 July 1991, p. 6.

**Television and Film**

'Stigma', David Livingston, dir., *Star Trek: Enterprise* (Hollywood, CA: Paramount,
5 February 2003)

'Profit and Lace', Alexander Siddig, dir., *Star Trek: Deep Space Nine* (Hollywood, CA:
Paramount, 13 May 1998)

'Rules of Acquisition', David Livingston, dir., *Star Trek: Deep Space Nine* (Hollywood,
CA: Paramount, 7 November 1993)

'The Outcast', Robert Scheerer, dir., *Star Trek: The Next Generation* (Hollywood, CA:
Paramount, 16 March 1992)

'The Host', Marvin Rush, dir., *Star Trek: The Next Generation* (Hollywood, CA:
Paramount, 13 May 1991)

*Star Trek VI: The Undiscovered Country*, Nicholas Meyer, dir. (Hollywood, CA:
Paramount Pictures, 1991)

'The Most Toys', Timothy Bond, dir., *Star Trek: The Next Generation* (Hollywood, CA:
Paramount, 7 May 1990)

**Online**

'Passion play'
Alexander Cho
*Frontiers.* 29 October 2005, http://www.frontierspublishing.com/features/feature_
second.html

'Gay Trek rumor light years ahead of reality'. 23 August 1996, http://www.glaad.org/ac-
tion/al_archive_detail.php?id=2354&

# IF SPOCK WERE HERE, HE'D SAY THAT I WAS AN IRRATIONAL, ILLOGICAL HUMAN BEING FOR GOING ON A MISSION LIKE THIS. SOUNDS LIKE FUN!

**CAPTAIN JAMES T. KIRK**
STAR TREK: GENERATIONS

Chapter
4

# Trek in the Park:
# Live Performance and
# *Star Trek* Fan Culture

Michael Boynton

→ Upon hearing about an annual theatrical production in Portland, Oregon called *Trek in the Park*, I knew it was a performance I needed to see first-hand. Simply, *Trek in the Park* takes a single episode of the original *Star Trek* series (1966-1969) and performs it live outdoors, much like a traditional play. The show is free and open to the public, where seating is unrestricted and primarily on the lawn, giving the event the overall feel of a summer concert. Established by the young amateur theatre company Atomic Arts in 2009,

Fig. 1: A replica of the iconic captain's chair from the original Star Trek television series awaits unveiling for a 'Trek in the Park' performance in Portland, Oregon. (Photo courtesy of Michael Boynton).

*Trek in the Park* immediately became a highly successful and defining facet of the new company. Founded by siblings Adam and Amy Rosko, Atomic Arts enjoyed immediate success with their performance of the episode 'Amok Time' (Episode 1, Season 2). This inaugural production was followed by 'Space Seed' (Episode 22, Season 1) in 2010 and then the performance of 'Mirror, Mirror' (Episode 4, Season 2) that I attended in 2011. Overall, the aesthetic interpretation of the episode attempts to maintain a high level of fidelity to the original script: *Trek in the Park* is not a parody or pastiche, nor is it a radical interpretation. Nor is *Trek in the Park* merely a slavish reenactment. In a general sense, *Trek in the Park* is what its title suggests it might be: a clean and simple (dare I say 'authentic') expression of an original *Star Trek* episode.

The sheer existence of *Trek in the Park* begs a number of questions. What sort of audience is attending these shows? Are these audience members *Star Trek* fans? What might *Trek in the Park* reveal overall about *Star Trek* fandom? Or theatre audiences? Or even scholarly approaches to performance and fandom in a general sense?

This chapter explores potential reasons why *Trek in the Park* is so well attended. And well attended and it is: by the end of their first season, each individual performance was attracting approximately one thousand audience members. During my visit on the opening performance of 'Mirror, Mirror', headcounts and sweeping photography of the crowd estimated an audience of 1,300. Many arrived three hours early and sat on the ground patiently to ensure they had a decent view of the action. Here was an informal amateur theatre company in its early years, performing a small-scale, hour-long show with no major spectacle or celebrities in a relatively small theatre city, yet attracting the sort of massive audiences that many famous professional theatre companies would die for.

In short, I suggest that *Trek in the Park* is able to attract large crowds not only because it is capitalizing on a popular property as its subject, but furthermore because its very form and context, its larger performance structure, help to foster a strong sense of community. In particular, *Trek in the Park* is a performance event that cultivates a range of communal engagements of various fan-related identity formations in a number of ways, a few of which this chapter intends to explore.

**Active audiences and participating fans**
Both performance studies and cultural studies (and especially fan studies) have been

## Trek in the Park: Live Performance and *Star Trek* Fan Culture
Michael Boynton

wrestling with the notion of audience, both theoretically and historically, since the 1990s. As evidenced in a number of early texts from both arenas, such as Susan Bennett's 1997 *Theatre Audiences* as well as Henry Jenkins's 1992 *Textual Poachers*, a primary issue is how active or passive an audience may be; that is, whether an audience member is a spectator or a participant. Roughly speaking, 'fans' may be considered audience members who are active participants, individuals who, to some degree, are involved with a given aesthetic object in such a way that they incorporate their intellectual and emotional interest in the object into their identity as well as into their social relationships. As more recent work in fan studies suggests, all of us in post-industrial, late capitalist western society are fans of something, be it baseball, *Star Trek*, news or even theatre.

But can the entire audience attending *Trek in the Park* be considered *Star Trek* fans en masse? There is little doubt in my mind, or even in the minds of the Atomic Arts artists themselves, that the association with *Star Trek* is the primary draw for its audiences. There are many free theatrical performances in the Portland area, but all pale in turnout. *Star Trek* is the reason for the well-attended season. That said, I would hesitate to uniformly classify every audience member as a *Star Trek* fan. Sure, there were a number of highly visible Trekkers in the classical sense, complete with cosplay Starfleet uniforms and pointy Vulcan ears. But the audience clearly comprised a wide range of Portlanders: families with children who felt *Trek in the Park* would provide a fun backdrop to their picnic, those who identified more as theatre fans than as *Star Trek* fans, and even a few passers-by who wanted to see what the big ado was. In other words, certain audience members attended to actively participate with their beloved cultural object but others were there for many sundry reasons.

Perhaps, then, *Trek in the Park* garners such large audiences because it somehow appeals to an exceptionally wide range of *Star Trek* fans. If fandom is seen less as an absolute and more as a spectrum, ranging from the most casual of fans to the most 'hardcore', then *Trek in the Park* is a performance event that permits a multiplicity of fan engagements and participations of varying depth. Both the most casual *Star Trek* spectators and the most adamant Trekkers can happily participate in their own respective fashions.

### *Star Trek* ... live and in person!
Another pivotal property of *Trek in the Park* that serves to nurture a sense of participating in a community is its liveness. Unlike the television viewer, an audience member is physically present during the act of artistic creation and watching that act with a number of other audience members. As such, the liveness of the performance suggests two important issues: first, that the audience can participate in the creation of the show itself, and second, that the audience can participate in the event with one another.

First, with live performance, the immediate, physical notion of presence suggests,

consciously or not, that the audience could alter or 'rewrite' the performance at any moment. This sort of interactivity can be as simple and benign as the actors' awareness of the physical presence of the audience, to the actors' adjustments to audience laughter and applause, all the way to full-scale audience participation, whether invited or disruptively aggressive. Many excellent theatre histories, especially those that deal with audience reception such as Gurr's 2004 *Playgoing in Shakespeare's London* or Ravel's 1999 *The Contested Parterre*, attest that live performance always carries the kernel of immediate participation. And while modern audiences may be seen broadly as more passive than our theatre-going ancestors (see, for example, Butsch's *The Making of American Audiences* [2000]) the potential for active participation can never be removed from live performance. As such, the liveness of *Trek in the Park* implies a participatory element analogous in certain respects to, say, writing *Star Trek* fanfiction. Because the show is live, audience members get to become a part of the story, and even perhaps to 'rewrite' the story more to their liking.

The second notion to consider is how the liveness of the theatrical performance also fosters social and communal interactions. As mentioned above, one of the defining characteristics of fandom is how fans build communities with other fans. The liveness of *Trek in the Park* makes the entire performance event a time for people to come together in person to share their interests. In this respect, the performance serves much of the vital identity and community-forming functions that occur at a typical *Star Trek* convention.

These functions are evident in the ritualistic, festival-like nature of *Trek in the Park*. Many audience members, particularly the regulars, arrive hours early both to stake out good seats as well as to socialize with one another. There are multiple picnics, various games and other communal pastimes accompanying the performance. These relaxed participatory activities recall a community carnival more than a traditional theatre performance.

### Star Trek ... in a park?

The concept of liveness alone, however, is only one of the ways that *Trek in the Park* fosters this sense of fan community. As both fan and performance scholars often note, the concepts of place (the immediate physical/architectural relationship between performance and audience) and space (the larger geographical environment in which the audience situates itself, be it local, national, global or virtual) are key concerns when understanding fan participations and performance as communal engagement. With *Trek in the Park*, place in particular is a defining aspect: the show is not performed in a traditional proscenium theatre, but rather outdoors.

As mentioned before, *Trek in the Park* feels more like a public festival than a traditional play: the outdoor format further contributes to this perception. There is also an inherent egalitarian appeal in the format of outdoor performances, especially in

**Trek in the Park: Live Performance and *Star Trek* Fan Culture**
Michael Boynton

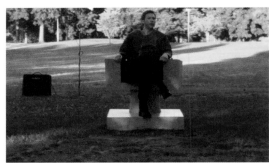

*Figs. 2 & 3: An actor assumes the role of Captain James T. Kirk in a live 'Trek in the Park' adaptation while audience members look on. (Photos courtesy of Michael Boynton).*

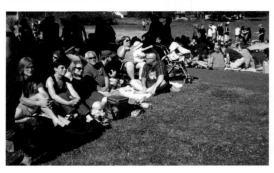

the United States, where 'in the park' performances, like the public parks themselves, capitalize on perceptions of public subsidization and equitable accessibility. Amateur outdoor performances, often free or at least highly afford-able, more often than not rely on this rhetoric of equality, more specifically a notion of bringing something useful or educational to the masses.

This notion of so-called equal-opportunity outdoor theatre raises the unmistakable parallel with Shakespeare in the Park. By performing *Star Trek* in a park – and further naming the event '*Trek in the Park*' – Atomic Arts has called upon a recent tradition of performing 'classics' outdoors, supplying culturally important performances to the mass-es. Could it be that providing the public access to classic episodes of *Star Trek* is operating in the same pedagogical vein as providing the public access to classic (or canonical) plays like *Hamlet* or *A Midsummer Night's Dream*?

Inescapable in comparison between *Trek in the Park* and the many incarnations of Shakespeare in the Park is the issue of cult versus canon or, rather, low and high culture. As Pearson indicates in her 2007 essay 'Bachies, Bardies, Trekkies, and Sherlockians', any difference between the fans of Shakespeare and *Star Trek* may be more perceived than actual: although certain Shakespeare aficionados may not confess it, they are es-sentially a type of fan as well. Still, there remains a lingering perception that Shake-speare is 'high art' (intimately tied to notions of cultural capital and cultural hegemony, if not colonization and imperialism) and that *Star Trek* is 'low art' at the bottom of the cultural totem pole.

Yet these perceptions are in flux. Many scholars argue that, as part of the postmodern condition, this binary of low and high culture is no longer as stable as it used to be. *Trek in the Park* is a fascinating example of a blending of the two. Outdoor performances of Shakespeare attempt to make Shakespeare more accessible to the middle classes and move him down the high/low hierarchy (where he may belong, given his popular appeal to the groundlings back in his own day). Paradoxically, performing the popular cultural object of *Star Trek* in a similar outdoor format, echoing its Shakespearean counterparts, attempts to move *Star Trek* up that cultural hierarchy. In many ways, *Trek in the Park* is a fascinating mix of both high and low, popular and elite, and a vehicle for simultaneously placing *Star Trek* in the hands of the public and reverently on a pedestal.

## Space ... not *just* the final frontier
As noted, space also plays an important role in establishing a communal relationship between particular audiences. For example, in theatre studies, it is commonly under-

stood that the neighbourhood or city in which a performance occurs impacts the per-
formance and vice versa. And just as traditional Broadway performances are intimately
tied with New York City and its Times Square environs, *Trek in the Park* owes much to its
connection to Portland.

In certain respects, *Trek in the Park* is a distinctly Portland event: produced by a local
company with local actors for a local audience. It takes place in a Portland public park,
further linking the show with the city. Furthermore, many of the people I talked with
– the theatre artists, the audience and various unaffiliated Portlanders around the city –
viewed *Trek in the Park* as a distinctively Portland institution: somewhat surprising given
its infancy. Perhaps the ultimate evidence of the local Portland connection was *Trek in
the Park*'s being featured in Season Two of IFC's satirical television series *Portlandia*
(Fred Armisen, Carrie Brownstein, and Jonathan Krisel, IFC, 2011-Present).

So why the powerful affinity between *Trek in the Park* and Portland? The answer may
lie in the cultural quirkiness of Portland itself. When I asked around for 'exceptionally
Portland' tourist destinations, I was directed downtown to Powell's City of Books, which
claims to be the largest independent new and used bookstore in the world, occupying
a full city block, and to Ground Kontrol Classic Arcade, where I was able to play some
classic video games. Portland is also home to Dark Horse Comics and Oni Press – small
graphic novel publishers. The number-one employer in the city is computer compo-
nents manufacturer Intel. Here was a city that was 'nerdy' and happily so. It's summed up
best by the popular Portland slogan 'Keep Portland Weird', which graces bumper stick-
ers around town. Given Portland's nerdy sensibility, perhaps it is not too far-fetched to
suggest that as a city supportive of fan identity, *Trek in the Park* was addressing a specif-
ic, local need for its surrounding community, and reinforcing a specific cultural identity.

**Fan nostalgia and performance**
Beyond the more formal performance properties of liveness, place and space, is the
concept of nostalgia, the re-experiencing of memory. Performance as re-experience,
as 'restored behaviour', and as a 'repertoire' of knowledge is a key tenet of performance
studies, one that can help to explore the strong affinity between fandom and nostalgia
for cult classics. In *The Haunted Stage*, theatre historian and theorist Marvin Carlson
(2003) suggests:

The retelling of stories already told, the reenactment of events already enacted, the
re-experience of emotions already experienced, these are and have always been central
concerns of the theatre in all times and places, but closely allied to these concerns are
the particular production dynamics of theatre: the stories it chooses to tell, the bodies
and other physical materials it utilizes to tell them, and the places in which they are told.
Each of these production elements are also, to a striking degree, composed of mate-
rial 'that we have seen before,' and the memory of that recycled material as it moves

# Trek in the Park: Live Performance and *Star Trek* Fan Culture
Michael Boynton

through new and different productions contributes in no small measure to the richness and density of the operations of theatre in general as a site of memory, both personal and cultural.

If live performance does indeed allow for a special sort of engagement with memory, then fan performances like *Trek in the Park* can be viewed as capitalizing on this particular incarnation of fan-based nostalgia. Carlson refers to this phenomenon as 'ghosting', which he says

presents the identical thing they have encountered before, although now in a somewhat different context. Thus, a recognition not of similarity, as in genre, but of identity becomes a part of the reception process, with results that can complicate this process considerably.

In this respect, *Trek in the Park* can be viewed as a 'memory machine' that allows its audience to engage in the process of identification through difference, through comparison, and, more accurately, through contrast with the 'original' *Star Trek* episode.

*Trek in the Park* may then be a powerful vehicle for memory and fan nostalgia, seen most vividly in the design aspects of the production and in the acting. The choices in costumes, props and sound are an integral part of the overall audience reception. Fan favourites such as the phasers and communicators, and the highly recognizable sounds that they make, elicit appreciation from the audience, as do the detailed recreations of the costumes from the original show. Much care and effort is taken by the designers of *Trek in the Park*, regardless of the low budget, to ensure a level of 'authenticity' is maintained.

The scenery is of particular note: the creation of the *Enterprise* bridge is achieved in a very minimal fashion. The crew sits on simple folding chairs, arranged in an arc recalling the original arrangement from the show. Kirk's famous Captain's chair, however, is thoroughly realized and well-constructed; an omnipresent piece of scenery placed centre stage. The only other major piece of scenery for 'Mirror, Mirror' was an empty archway serving as a door, which allowed for both a wall-mounted communication panel as well as the telltale 'swish' of the door opening. Envisioning the rest of the setting is left to the audience, whether the scenes took place on the *Enterprise* or on an alien planet. While at first it may seem an unusual juxtaposition performing a technology-driven outer space science fiction piece in such a minimalist natural setting, the bare surroundings only served to emphasize the two set pieces present. As such, the door-frame and most especially the Captain's chair enabled a strong nostalgic connection for the audience. After the show, many audience members made it a point to come up and appreciate the chair and to pose for photographs.

As for acting, *Trek in the Park* prides itself on treating the piece as a piece of thea-

tre. According to Artistic Director Adam Rosko (28 May 2012 interview), 'I wanted to make sure we didn't go overboard and make it just a reenactment; it has to still be a play, using only the tools that are normally used in live outdoor theatre.' The inevitable minor deviations are most pronounced in the portrayal of the highly familiar roles of *Star Trek*, which have entered the pantheon of popular cultural knowledge. One of the biggest attractions for fans is to see how the actors of *Trek in the Park* compare to their iconic mediated originals. Key roles are played each season by the same actor, which serves to deepen the audiences' critical comparison of the actors' performances. This process recalls theatre scholar Joseph Roach's concept of 'surrogation', where performers attempt to step into roles that were once inhabited by another. Inevitably, the process is not perfect: in both physical body and character interpretation, the original actor can never be fully produced. As Roach maintains in *Cities of the Dead* (1996), 'The intended substitute either cannot fulfill expectations, creating a deficit, or actually exceeds them, creating a surplus.' In this way, the 're-acting' of *Trek in the Park* simultaneously encourages nostalgic remembrances of the original actors as well as fosters an audience's active participation, enabling them to critically compare and contrast 'the intended substitute'. Furthermore, re-experiencing *Star Trek* through performance in this nostalgic fashion reinforces an individual's fan identity on a deeply personal level, which is immediately affirmed as a communal activity given the overall context of the performance event.

### Fan identity, fan community

Between the surrogation of iconic roles and the various design elements, *Trek in the Park* serves as both a nostalgic recapitulation of the original series as well as a vehicle for active fan participation. This brings us full circle: as seen with the formal properties of liveness, place and space, audience participation is clearly a key component of *Trek in the Park*'s successful reception. Even more specifically, I would argue that *Trek in the Park* has found a performance structure that not only allows a wide range of audience participations and identities, but also nurtures them in an atmosphere of social and communal equality. In short, *Trek in the Park* is not judgmental: whether you have never seen *Star Trek* before or have memorized every line of every episode, you are made to feel welcome and part of the fun. As such, the supportive communal atmosphere offers individuals the opportunity to openly express their fan or non-fan identity as they please.

And here, perhaps, is the primary reason behind *Trek in the Park*'s enormous audiences: in making a wide range of audience involvement equally possible, from the most hardcore Trekker to the bemused dilettante, from the harshest critic to the most idealistic supporter, the production does not limit its appeal. Furthermore, reception occurs in an environment free from both the minutiae-laden critiques of 'Trekkies' and the pathologizing of ardent fans by the more dispassionate.

**Trek in the Park: Live Performance and *Star Trek* Fan Culture**
Michael Boynton

What, then, might *Trek in the Park* reveal about *Star Trek* fandom? At the very least, its audience reception demonstrates that *Star Trek* fandom is still very much alive and well today. More importantly, it also reveals that *Star Trek* fans come to performances of its texts with varied expectations for entertainment, engagement and participation. In this case, *Star Trek* fans today are as committed to participating with the crew of the NCC-1701 in the exploration of strange new worlds, whether among the stars or beneath them. ●

## GO FURTHER

**Books**

*Shakespeare and Amateur Performance: A Cultural History*
Michael Dobson
(Cambridge: Cambridge University Press, 2011)

*Playgoing in Shakespeare's London* (3rd. edn)
Andrew Gurr
(Cambridge: Cambridge University Press, 2004)

*The Archive and the Repertoire: Performing Cultural Memory in the Americas*
Diana Taylor
(Durham, NC: Duke University Press, 2003)

*The Haunted Stage: The Theatre as Memory Machine*
Marvin Carlson
(Ann Arbor, MI: University of Michigan Press, 2003)

*The Making of American Audiences*
Richard Butsch
(Cambridge: Cambridge University Press, 2000)

*The Contested Parterre: Public Theater and French Political Culture, 1680–1791*
Jeffrey Ravel
(Ithaca, NY: Cornell University Press, 1999)

*Theatre Audiences*
Susan Bennett
(New York: Routledge, 1997)

*Cities of the Dead*
Joseph Roach
(New York: Columbia University Press, 1996)

*Textual Poachers: Television Fans and Participatory Culture*
Henry Jenkins
(New York: Routledge, 1992)

*Between Theater and Anthropology*
Richard Schechner
(Philadelphia, PA: University of Pennsylvania Press, 1985)

*The Making of American Audiences*
Richard Butsch
(Cambridge: Cambridge University Press, 2000)

### Extracts/Essays/Articles

'Bachies, Bardies, Trekkies, and Sherlockians'
Roberta Pearson
In Jonathan Gray, Cornel Sandvoss and C. Lee Harrington (eds). *Fandom: Identities and Communities in a Mediated World* (New York: New York University Press, 2007), pp. 98–109.

### Other

Interview with Adam Rosko
Michael Boynton (via Skype, 28 May 2012)

Chapter
5

# Assimilate This! Computer-Mediated Communication and *Star Trek* Fan Culture

Kimberly L. Kulovitz

→ Decades ago *Star Trek* fans relied on organizing face-to-face conventions and groups to celebrate their cultural ties to the vehemently popular television series. While in-person fan festivities are still popular, a new and expansive territory emerged with the development and growth of Internet and website capabilities. From fan-created blogs to 'official' *Star Trek* updates and merchandising, assimilation into the world of *Star Trek* fan culture is relatively easy; however, there has been little systematic study concerning how computer-mediated communication (CMC) helps *Star Trek* fans negotiate their culture.

*Fig. 1: Some online fans of Star Trek: Enterprise would have preferred plots stressing a sexual relationship between Trip (right) and the Vulcan T'Pol. Image © Paramount Pictures.*

*Star Trek* has sustained nearly 47 years of cultural stardom, produced five television series, twelve movies and an animated series, a repertoire rarely duplicated. In addition to these syndicated and studio-sanctioned accomplishments are the immeasurable contributions by the fans. From fan-created movies and cosplay (costume play) to blogs and conventions, the fans themselves enthusiastically maintain the *Star Trek* universe. This chapter uses Joseph Walther's hyperpersonal model of CMC to examine how through 'heightened levels of intimacy, solidarity and liking' *Star Trek* fans create and maintain their culture online. Content analysis of public fan forum posts will be used to assess specific components of the hyperpersonal model, further exploring the online world of *Star Trek* fans.

**Rationale**

*Star Trek* is not simply another television show or a summer movie for a rainy day; it is, as noted by American Space historian Dwayne Day in 2011, a science fiction phenomenon that frames and reflects the underpinnings of our everyday society. From militarism, sexism and racism to peace, liberation and relationships, *Star Trek* places our everyday encounters and world events into future space and time. Placed just far enough ahead of present day, it is both a reflection of current events and a warning of what might be. As noted by William Shatner in his documentary *The Captains* (2011), anecdotally many people have credited the *Star Trek* series for their current career choices, life paths and relationships. Historically, the original series (*ST: TOS*), broadcast 1966 to 1969, featured the first multi-racial kiss on TV, and was withdrawn from cancellation after a fan-led letter-writing campaign petitioned network executives. Whether it is the duality of the genre, the meaning placed on the series by the fans, or the historical significance of the original series, it is impossible to ignore *Star Trek*'s continued popularity.

While *ST: TOS* occurred at a time when the Internet itself was nothing more than science fiction, *Star Trek* fan culture online grew and developed quickly with improving Internet capabilities. What is significant about this online interaction amongst fans, according to media scholar Henry Jenkins (1988), is the power that the Internet gives fans to shift from spectator to participator, which ensures that participating and negotiating online fandom is a cultural activity. What once was an activity that occurred only in face-to-face encounters and required synchronized time and nonverbal cues now

Assimilate This!
Computer-Mediated Communication and *Star Trek* Fan Culture
Kimberly L. Kulovitz

transcends these boundaries.

## What is computer-mediated communication?

Computer-mediated communication was described in the early days of the Internet by scholar Joseph Walther (1992) as 'synchronous or asynchronous electronic mail and computer conferencing' and while this is still accurate, the definition has expanded far beyond conferencing and e-mail. CMC is typically either synchronous communication that occurs in real time and space (e.g. face-to-face), or asynchronous communication that is staggered through time and space (e.g. e-mail), and includes any form of communication assisted by an electronic device. This includes e-mail, instant messaging, social networking sites such as Facebook, and voice and video call services such as Skype. As our technology changes, so too does the way in which we communicate; thus, the definition of CMC is constantly evolving with the rise of new technological innovations. It is important to keep in mind that it is not the technology itself that is important to the study of CMC, but rather how people are using the technology to form new relationships, maintain existing relationships, and manage impressions.

## Impersonal, interpersonal, and hyperpersonal

The hyperpersonal model of computer-mediated communication emerged to help explain why communication occurring online was at times more manageable and more desirable than face-to-face communication. While *impersonal* communication is detached, objective and task-oriented and *interpersonal* communication is interactive and relationship-oriented, *hyperpersonal* communication provides selective self-presentation and idealized impression management through CMC channel control. Joseph Walther noted that this channel control allows levels of affection in CMC to, at times, move beyond that of a comparable face-to-face encounter and may make CMC the more socially desirable option.

Hyperpersonal communication takes advantage of the technology, allowing users to manipulate the media to, according to Walther (1996), 'enhance their relational outcomes' and 'facilitate desired relationships'. This is because the technology of CMC (e.g. Skype, text messaging, etc.) when compared to equivalent face-to-face interactions is more editable, allows more time for message creation, is physically isolated from the receiver, and allows for greater thought to be put towards message creation. For example, someone seeking to start a romantic relationship with a coworker may choose the CMC channel of text messaging, editing the message several times before sending and spending extra time thinking about what to write, something that could not be accomplished if the two people were standing in front of each other.

As technological innovations permeate the world of CMC, the conceptualizations of hyperpersonal communication have further developed. As described by Joseph Walther, there are four primary components of the hyperpersonal model of CMC that

account for the theoretical structures of the model: selective self-presentation, idealization, channel management and feedback. Selective self-presentation refers to the presentation control that CMC users have over their self-presentation so that they can 'exaggerate intended characteristics and diminish unwanted ones'. Idealization denotes the tendency of CMC users to 'fill in the blanks' regarding the characteristics and personalities of other CMC users, while channel management occurs when CMC users manipulate the editable features of the media. Finally, feedback reinforces and intensifies self-presentation, idealization and channel management through the reactions of other CMC users.

### Characteristics of *Star Trek* fan culture and communication

Although *Star Trek* fans often distinguish between being a 'Trekkie', the more socially stigmatized reality-averted fan, or a 'Trekker', the more traditional convention-goer, both are part of the larger fan culture and share noteworthy characteristics. As Patricia Byrd noted in 1978, early in the *Star Trek* franchise fans were already differentiating themselves by creating their own slang, vocabulary and associated acronyms, proving through use of language that they were part of the fan group. According to Sam Ford (2006), additional fan culture affiliation is based on the sharing of 'intimate personal experiences' and behaviours that 'extend far beyond pure enjoyment of the media', including discussing interpersonal relationships, seeking social support, or any other type of relationship-based behaviour that does not include discussion of the *Star Trek* franchise.

While *Star Trek* fans share common ground through jargon and general group affiliation, fans also exist as a unique vernacular culture, which ensures fan participation. Vernacular cultures, according to Kris Markman (2005), 'are those arising from and produced for the people themselves', which places *Star Trek* fan culture apart from network-associated mass content (e.g. the 2009 *Star Trek* movie by Director JJ Abrams) and pure appreciation for the mass culture. As participants in a vernacular culture, fans can share their interpretations of and appreciation for the *Star Trek* universe, motivated by a desire to connect to other fans, fill in the gaps and explain contradictions.

### Methods

Two public *Star Trek* forums were selected for analysis: the first from *Startrek.com*, the official *Star Trek* website licensed by franchise owner CBS Studios Inc., and the second from *Trekbbs.com*, a fan forum site not affiliated with CBS Studios Inc. At the time of selection, the forum with the most recent post that had at least 75 overall posts was selected for analysis. Forum administrator posts, polls and announcements were excluded from selection. The *Startrek.com* forum was titled 'The Reason *Enterprise* Died', contained 173 total posts, and was started on 5 January 2012. The *Trekbbs.com* forum was titled 'Anyone else sick of *Star Trek* fans being called "geeks"?', contained 86 posts, and

**Assimilate This!**
**Computer-Mediated Communication and *Star Trek* Fan Culture**
Kimberly L. Kulovitz

was started on 30 May 2012.

It was free to register for both *Startrek.com* and *Trekbbs.com* forums, which included customized profiles, options and personal information. It was not necessary to register to view posts, only to post replies or comments, although, in addition to free registration, *Trekbbs.com* also offered premium paid membership for 25 dollars per year, which allows users private messaging, no advertising and access to non-public forums. This analysis only obtained information from public forums and did not directly solicit those posting in the forums for any information.

To analyse the forums for the presence of hyperpersonal communication, a deductive content analysis using an open coding scheme was performed (see Bereleson 1952; Elo and Kyngas 2008, for further information). This is a combination method that relies on previous studies 'such as theories, models, mind maps and literature reviews', as well as inductive analysis. In this analysis, categories were created based on the hyperpersonal model; however, open coding was also utilized to allow for an inductive reading of the text in the event that additional coding categories emerged.

Coding categories based on the hyperpersonal model of communication for both forums included selective self-presentation, idealization, channel management, feedback and solidarity. Selective self-presentation was defined as the exaggeration of good qualities and the diminishing of bad qualities (only at the individual level), while idealization was characterized as the purposeful disregard for the imperfections of others (either at a group or individual level). Channel management was recognized as manipulation of the editable features of the forum (e.g. posting of pictures, screen name choice and emoticons), and feedback was defined as reinforcement of self-presentation, idealization and channel management or a reaction to or return of information. Finally, solidarity was represented as group unity or mutual support.

### Selective self-presentation

Selective self-presentation was consistent through both Startrek.com and Trekbbs.com forums; however, each forum demonstrated slightly different aspects of individual personalities being emphasized or de-emphasized. Star Trek fans posting in both Startrek. com and Trekbbs.com exaggerated their education or the amount of knowledge they had about a given topic, which in most cases was about the world of Star Trek. Most likely as a result of the topic of the forums, Startrek.com posters tended to amplify their knowledge of the Star Trek canon, while Trekbbs.com posters were inclined to exaggerate their indifference to the 'geek' label.

Posts that exaggerated the amount of expertise posters had regarding the Star Trek universe were repeated continuously through both the Startrek.com and Trekbbs.com forums. For example, in response to another poster on Startrek.com, Mitchz95 stated, 'which time travel episode? There were at least five' (line 381), demonstrating to others in the forum that s/he has at least some knowledge of Star Trek. This quote also

*Fig. 2: The Enterprise faces a pair of Romulan "warbirds" with the ability to "cloak" themselves. Image © Paramount Pictures.*

indicated that Mitchz95 was more knowledgeable than the poster s/he was replying to since s/he was asking for specific episode clarification. Additionally, in response to the original poster in Trekbbs.com, Sindatur stated, 'take advise [sic] from Uhura, words are only words, they can't hurt you if you don't let them' (line 083), suggesting not only that the original poster seek further advice from the Star Trek universe, but also revealing the respondent had at least a base familiarity with Star Trek through his/her quotation of an original Star Trek character.

In addition to demonstrating their understanding of the Star Trek universe, forum posters in Startrek.com distinctly exaggerated their knowledge of 'the canon', while Trekbbs.com posters exaggerated their tendency to not be bothered by being called 'geeks'. For example, several Startrek.com posters revealed their exceptional knowledge of the canon in this sampling:

Antoninus Pius: Excuse me [...] I do believe there is a canon problem with the Romulans having cloaking devices on their ships [...] if there isn't please explain it to me. (line 1042)
T'adam: 'I have to disagree. I like the fact that they managed to keep thinkgs [sic] canon over so many years. (line 1424)

These passages suggest that the authors have extensive knowledge of the canon of Star Trek through pure disagreement with other posters discussing the canon as well. It is through this disagreement that the posting authors are able to position their self-presentation in such a way that highlights their overall comprehension of the Star Trek universe.

Most Trekbbs.com forum posts are in direct response to the original poster's question ('Anyone else sick of Star Trek fans being called "geeks"?') and distinctly highlight the fact that they are not bothered by being called a geek. Posts such as the following permeate the Trekbbs.com forum:

bbailey861: I have good friends, a great family, a cool job, fun hobbies – and I am a geek. Nope, it doesn't bother me at all. (line 306)

Admiral James Kirk: I don't give a fuck about being called a geek. I am a geek. It's alright [sic] to be a geek in this day and age. Geek is chic. [smiley face w/sunglasses] (line 339)

While posts such as the ones by bbailey861 and Admiral James Kirk highlight that they are not at all troubled by being called a geek, they rationalize their self-presentation in different ways. bbailey861 presents him/herself as socially well-adjusted (e.g. good job, nice family) while Admiral James Kirk takes more of an incensed self-presen-

Assimilate This!
Computer-Mediated Communication and *Star Trek* Fan Culture
Kimberly L. Kulovitz

tation to reveal how not bothered s/he is by the geek label (e.g. using profanity). Most telling in these two particular comments is the fact that they both declare 'I am a geek', self-identifying that 'geek' is part of their online identity, an occurrence that was repeated throughout the forum.

### Idealization and solidarity: Us vs them
Idealization is closely connected to the exaggerated self-presentation demonstrated by the forum participants above; however, instead of exaggerating or representing perfection for the self on an individual level, participants in the forums idealized Star Trek fans as a group. Unexpectedly, this idealization of Star Trek fans in both forums led to an 'us fans vs those others' mentality, which in turn led to examples of solidarity amongst group members. This combination of fan group idealization, group cohesion and polarization of outsiders seems to rationalize continuity between both individual and group identities.

The idealization present in Trekbbs.com idealizes the Star Trek fan as financially stable, smart, socially well-adjusted and technically skilled. For example, Sindatur posted, 'Geek kids will often fare far better financially later in life' (line 98) in reference to Star Trek fans being proud to be geeks; this is also echoed by BillJ who posted, 'Geek implies we're smart' (line 222). Additionally, Gary7 posted, 'this is particularly evident in the technical disciplines' (line 379), referencing being a fan, a geek and having lucrative employment.

Trekbbs.com forum members also used phrases such as 'we' and 'us' to set themselves apart from the non-fans they were speaking of, even going as far as to refer to 'others' or non-fans in derogatory terms such as idiot, snob and haters. For example, C.E. Evans called the non-fans 'haters' and 'self-loathers' (line 22), Propita referred to them as 'idiots' (line 363), and MacLeod said non-fans were 'ridiculously literal minded' (line 1396) to identify just a few of the incidents of name-calling. This labelling of both fans and non-fans not only starkly contrasts the groups, but tends to create solidarity among members of the Star Trek fan group. Group cohesion is achieved through the categorization and idealization of one group over the other.

### Channel management
Channel management is another component of the hyperpersonal model that was present in both the sampled forums from Startrek.com and Trekbbs.com. Both forums allowed for unlimited customizability, which allowed for precise channel management. The only features on Startrek.com and Trekbbs.com that were not editable were the number of posts that a forum participant sent; all other features were editable. Specifically, forum participants were able to rewrite posts, select screen names and the pictures associated with screen names, use emoticons, post pictures, post recurring quotes and phrases in the signature lines of their posts, and control links to other sites.

For instance, Chemahkuu on Trekbbs.com posted a picture of actor Simon Peg with a built-in quote as a response to another poster instead of writing a text-based post.

### Feedback

Feedback within the forums saturated countless posts; however the most prevalent example of reaction to a particular post was when one participant connected Star Trek and pornography. Ghostmojo suggested that Star Trek: Enterprise (2001–05) should have been 'sexed up' a bit and that the network should have 'gone for a steamy late night version of Trek showing some actual Trip/TPol bonking' (line 013). Mitchz95 was the first to respond with, 'I hope you're joking. Seriously, there's absolutely NO CONCEIVABLE EXCUSE for making Star Trek a porn show' (line 395). Mitchz95 used all caps to emphasize his/her discontent with even the possibility and Ghostmojo's idea was not only quickly dismissed by others, but also never revived past a single post. Feedback like this creates online conversation and sets the norms for those fans posting in these particular forums.

### To boldly go ... online!

One major question concerning hyperpersonal communication in the *Trekbbs.com* and *Startrek.com* forums should be addressed: do any of the categories exist beyond what can be obtained face-to-face? This is hard to say definitively, but it is appropriate to assume based on the above evidence that it would be difficult to maintain at least some of the conversations and relationships offline. It appears that there are certain discussions that could be maintained only with the anonymity allowed by channel management, selective self-presentation and idealization. Additionally, forum participants from all of the United States and Europe consistently maintained conversations, feedback and relationships within the forums, something that could not have been maintained offline with the same amount of ease. Through every carefully chosen screen name, posted picture and pop culture reference, the world of *Star Trek* and the fans who love it flourish online. ●

### GO FURTHER

### Books

*Content Analysis in Communication Research*
Bernard Berelson
(New York: Free Press, 1952)

### Extracts/Essays/Articles

'The cyber factor: An analysis of relational maintenance through the use of computer-

**Assimilate This!**
**Computer-Mediated Communication and *Star Trek* Fan Culture**
Kimberly L. Kulovitz

mediated communication'
Marian L. Houser, Christina Fleuriet and Dawn Estrada
In *Communication Research Reports*. 29: 1 (2012), pp. 34–43.

'The effect of feedback on identity shift in computer-mediated communication'
Joseph B. Walther, Yuhua Liang, David C. Deandrea, Stephanie Tom Tong, Caleb T. Carr, Erin
L. Spottswood and Yair Amichai-Hamburger
In *Media Psychology*. 14: 1 (2011), pp. 1–26.

'The qualitative content analysis process'
Satu Elo and Helvi Kyngas
In *Research Methodology*. 62: 1 (2008), pp. 107–15.

'Selective self-presentation in computer-mediated communication: Hyperpersonal dimen-
sions of technology, language, and cognition'
Joseph B. Walther
In *Computers in Human Behavior*. 23(5) (2007), pp. 2538–57.

'Utopian enterprise: Articulating the meanings of *Star Trek*'s culture of consumption'
Robert V. Kozinets
*Journal of Consumer Research*. 28(1) (2001), pp. 67–88.

'Computer-mediated communication: Impersonal, interpersonal, and hyperpersonal interaction'
Joseph B. Walther
In *Communication Research*. 23: 1 (1996), pp. 3–43.

'Interpersonal effects in computer-mediated interaction: A relational perspective'
Joseph B. Walther,
In *Communication Research*. 19: 1 (1992), pp. 52–90.

'*Star Trek* rerun, reread, rewritten: Fan writing as textual poaching'
Henry Jenkins
*Critical Studies in Mass Communication*. 5: 2 (1988), pp. 85–107.

'*Star Trek* lives: Trekker slang'
Patricia Byrd
In *American Speech*. 53: 1 (1978), pp. 52–59.

**Film/Television**

*The Captains*, William Shatner, dir. (Vancouver, CA: Entertainment One, 2011)

**Online**

'Anyone else sick of *Star Trek* fans being called "geeks"?'
*Trekbbs.com*. 30 May 2012, http://www.trekbbs.com/showthread.php?t=177742

'The reason *Enterprise* died'
*Startrek.com*. 5 January 2012, http://www.startrek.com/boards-topic/33350801/the-reason-enterprise-died

'*Star Trek* as a cultural phenomenon'
Dwayne Day
3 November 2011, US Centennial of Flight Commission http://www.centennialofflight.gov/essay/Social/star_trek/SH7.htm

'*Star Trek* fan culture and community building: An essay from Lincoln Geraghty'
Sam Ford
29 December 2006, Futures of Entertainment http://www.convergenceculture.org/weblog/2006/12/star_trek_fan_culture_and_comm.php

'Trekker vs. Trekkie: The Controversy'
Fran Black
7 November 2006, Unexplainable Frequencieshttp://www.unexplainable.net/space-astrology/trekker_versus_trekkie_the_controversy.php

'*Star Trek*: A phenomenon and social statement on the 1960s'
William Snyder, Jr
1995, The Most Excellent Home Page of Will Snyderhttp://www.ibiblio.org/jwsnyder/wisdom/trek.html.

**Other**

'Star trek, fan film, and the internet: Possibilities and constraints of fan-based vernacular cultures'
Kris M. Markman
Conference Paper, International Communication Association, 2005. Communiation: Questioning the dialogue. New York City, NY, USA.

Chapter
6

# Lost in Orbit:
# Satellite *Star Trek* Fans

## Bianca Spriggs

→ **Last year on a sweltering day in July, I was sitting in a tattoo artist's chair, having an image of the USS *Enterprise*, NCC-1701-D, inked into my right inner forearm. After over a quarter of a century spent following the *Star Trek* franchise, as the needle whined its way into my skin, I realized quite abruptly that I'm now a right proper *Star Trek* fan.**

*Fig. 1: President Obama and Star Trek cast member Nichelle Nichols display a Vulcan salute in the Oval Office. Image © USA Today.*

Even my cellphone's ringtone, the theme music to *Star Trek: The Next Generation* (*ST: TNG*, 1987-1994), can bring back immediate visions of piling into the living room with my family on Saturday evenings with boxes of pizza and lap trays – a weekly splurge – to watch the *Enterprise* crew wrangle the challenges and triumphs of the universe. For a couple of hours each week, my parents' differences were set aside in exchange first for reruns of Jim, Spock and Bones, followed by Picard's wit versus Q's, Data's struggle to understand humanity and the eminent threat of the Borg. Instead of sports or character cartoon cards, as a child, I collected *Star Trek* cards featuring my favourite crew members and slid them into the plastic pages of my family's photo album. In a household more often fraught with friction than not, including a lot of moving around from state to state, the constant presence of the *Star Trek* franchise had become a reliable, stable and positive factor in my day-to-day reality as well as my burgeoning creative aesthetic.

But I never really considered myself a legit part of the fan culture. I wasn't among that sect Shatner might tell, as he did in a memorable *Saturday Night Live* (Lorne Michaels, NBC, 1975-Present) sketch in 1986, to 'Get a life'. I didn't spend time learning Klingon phrases, cash in my savings to attend a convention, or visit fan forums (although I do admit to occasionally following the virtual adventures of Wil Wheaton and George Takei). Heck, I didn't even discuss *Star Trek* with anyone except my husband and immediate family. I just sort of watched and re-watched the episodes and films, some of the documentaries, and thought a lot about the 'Prime Directive'.

One day about a year ago, on a whim, I posted as my Facebook status update 'Darmok and Jalad at Tanagra', not really thinking anyone except my sister and perhaps one other person would get the allusion to an attempt at alien communication from an episode on *ST: TNG*. Dozens of 'likes' and affectionate comments later, I realized I'd stumbled upon a trove of *Star Trek* fans buried among my 'friends'. Even more surprising, however, was the fact that among them were actual friends I'd known for years, some a decade or more, without knowing anything of their affinity for *Star Trek*.

There is something oddly personal about engaging the utopic mythos of the *Star Trek* universe and its inhabitants, a pervasive blue note, if you will, that engages viewers to automatically insert themselves into the narratives through internalizing or empa-

## Lost in Orbit: Satellite *Star Trek* Fans
Bianca Spriggs

thizing with the experiences of the characters.

*Star Trek* Fan Culture (*STFC*) goes far beyond the preference for considering one-self a 'Trekkie' versus a 'Trekker'. This chapter focuses on featuring the *Star Trek* experiences among what I call 'satellite fans' or, rather, the members of the *STFC* who operate more along the lines of enthusiasts, expressing a devoted loyalty that is difficult to lampoon. These are the fans who, I would argue, are every bit as knowledgeable about the franchise as the fans who are publishing fanfiction and YouTube videos. Through personal interviews, I will showcase members of the *STFC* who are just as responsible for keeping the franchise alive as their more visible counterparts. Overall, their answers to my questions are just as varied as the individuals, and so, because of space limitations, the interviewees I have chosen to include were selected based upon their openness and expressiveness.

The best way to come to know fans and fan culture is through the words of the fans themselves. So, I encourage you to continue reading as though you were just transported to the Ten Forward lounge from *ST: TNG* or Quark's Bar from *Deep Space Nine* (*ST: DS9*, 1993-1999), and we're all sitting around enjoying a freshly poured pint of Arcanis Lager. It is my hope that, like me, you will see some of your own experiences in theirs, ultimately adding to this intelligent, creative and exceptionally cool sampling of fan culture.

### What is your earliest memory of *Star Trek*?

'My earliest memory of *Star Trek* is sitting on the couch in my living room watching reruns of the original series [*ST: TOS*, 1966-1969] with my father […] The shows gave us something to talk about, allowed our imaginations to run wild, and expressed a lot of the lessons that he was trying to teach me at that time about friendship, love, honor, and family' – Nathan Pendleton, Lawyer, hereafter, NP.

'My earliest memory of *Star Trek* was [*ST:*] *TNG*. For my family, it was an event, like the unveiling of a new Michael Jackson movie. We watched the premiere of the first episode together in a brass, glass, and pastel eighties living room' – Shayla Wolfs-Lawson, Writer, hereafter, SWL.

'Watching a snowy picture of the *Enterprise* from [*ST:*] *TOS* on WAVE-3 out of Louisville. This would have been in the early to mid-1970s and happened every Sunday morning at 11:00' – Kenneth Moorman, Professor of Computer Science, hereafter, KM.

'My earliest memory of *Star Trek* is getting to stay up late on Friday nights to watch reruns of [*ST:*] *TOS*. It had the slot just after *The Honeymooners* on WPIX in the mid-1980s before *ST: TNG*' – Dante Micheaux, Poet, hereafter, DM.

'*ST: TNG* turned 25 years old in 2012, as did I. I quite literally grew up with the show, so watching [*ST:*] *TNG* was definitely something that I spent my childhood doing. Watching the show with my grandfather when I was very young is definitely a happy memory that I have. I would often mimic the character Geordi La Forge by putting a headband over my eyes to imitate his VISOR' – Natasha Lee Collier, Contributor to *Word of the Nerd*, hereafter, NLC.

'My earliest memory of the show was of my father watching *ST: TOS* during [its] syndication runs on Nick-At-Night' – Craig Crowder, Ph.D. Candidate, hereafter, CC.

**At what point did you consider yourself to be a fan?**

'I have never known a day in my life where I was not a *Star Trek* fan' – NP.

'At first, it was the thing I would do to connect with my dad. My dad is a doctor and was not at home much. But he'd been a *Star Trek* geek as a kid [...] and by default [that] became my inheritance. I enjoyed *ST: TNG* because of the role models it presented. The people of color were intelligent and unapologetic. I remember being around five or six and telling a neighborhood girl I had a crush on Worf and being laughed at pretty unrelentingly' – SWL.

'I considered myself a fan by season three of [*ST:*] *TNG*. I was 9 years old and the third season debuted around the same time as the school year started. I had also received my first color TV. [*ST:*] *TNG* was my after-homework treat on Monday nights' – DM.

**In your opinion, what distinguishes *Star Trek* from other science fiction franchises?**

'The primary idea behind *Star Trek*, plain and simple, is exploration. Venturing into the unknown and seeing what's out there. In imagining what we have not yet seen, the show obviously (and sometimes rather obtusely) develops parables to help us make sense of what we already know of as reality. Other science fiction series tend to be about technology rather than humanity' – NP.

'From early on, *Star Trek* managed to create a world that we wanted to become possible. Uhura could be sexy and indispensable. Wesley Crusher could be a lovable wunderkind [...] The characters were based on realistic premises that challenged conventional TV archetypes. The show claimed to represent space but the final frontier really translated in the form of humanity' – SWL.

'There's the obvious stuff: it's the longest running franchise (with the possible excep-

**Lost in Orbit: Satellite *Star Trek* Fans**
Bianca Spriggs

*Fig. 2: A replica of Quark's
from Star Trek: Deep Space
Nine in Las Vegas.
Image © Gary Goddard
Entertainment + Design.*

tion of *Doctor Who*), the most commercially successful, has spawned the most movies and series. But the thing that makes *Star Trek* the best sci-fi franchise – and the thing that distinguishes it from similar franchises – is the show's ability to take what are essentially stock characters in the genre [...] and employ them in a way that is consistently engaging' – CC.

## What kind of impact do you feel *Star Trek* has made on general culture at large?

'[*ST:*] *TOS* was produced in a time of intense racial tension and fear of Communist subversion in America, yet the show presented the viewers with a completely diverse bridge crew. Money no longer exists, so racial division and class systems are also extinct, producing a perfect socialist society without ever losing its cultural identity as uniquely American [...] Much like [*ST:*] *TOS*, [*ST:*] *TNG* gave us a plethora of positive black and female characters [...] Both shows not only provide a certain examination of the prevailing social paradigms of their time but they also allow the viewer the opportunity to examine the issues for themselves from a safe distance, and make their own conclusions' – NP.

'I like the picture of Uhura and President Obama making the "live long and prosper" sign in the oval office. And how the same sign was appropriated by N.E.R.D. during their fledgling tour' – SWL.

'A common narrative where a wide audience knows many of the references even if they have never seen the show' – KM.

'I think it has made a great impact in creating scientific interest in the average person. *Stars Wars* [sic] was too far removed from our actual experience to have a connection beyond mere fantasy. *Star Trek* gave us a plausible explanation for why we would be out in the universe and how we might conduct ourselves when encountering other sentient beings. And speaking of "sentient", *Star Trek* did wonders for the American vocabulary' – DM.

'There is an interesting relationship between *Star Trek* and NASA that can be examined here. Through a large-scale letter writing campaign, fans convinced NASA to name one of the space shuttles "The Enterprise", though it never went into space' – NLC.

'The fact that *Star Trek* has consistently put out quality story-telling in so many modalities over five decades (and done so lucratively) has encouraged other writers to produce films/shows/books in the sci-fi fantasy genres. This is an economic reading of the series' impact: the fact that *Star Trek* has been able to turn a profit has enabled other stories to be told in the genre, which has broadened the definition of what is socially

acceptable in terms of storytelling' – CC.

## Which is your favourite series in the franchise? Why?

'[ST:] TOS, purely for sentimental reasons, but also because of the certain naïveté that the show proceeds upon. Kirk, to me, is the more romanticized idea of Horatio Hornblower. He is not a statesman so much as a commander [...] But Kirk, as difficult as he can often be, is tempered by his two friends, McCoy and Spock [...] But this triumvirate also extends into their personal lives'– NP.

'[ST:] DS9. My parents were friends with Bernard Harris before his NASA flight and he was around during much of my very early childhood. It wasn›t much of a stretch to see him in a space suit after years of watching Star Trek on television. It seemed both progressive and normative' – SWL.

'ST: DS9 was my favorite series. I actually got watery-eyed at the end of the last episode when the cameras pan away from the "station" and, after six years, one realizes just how far away the characters were in space' – DM.

'ST: TNG is definitely my favorite. I particularly enjoy the treatment of the Prime Directive, which states that there can be no interference with the development of alien civilizations. The characters in [ST:] TNG have to wrestle with this concept and examine their own humanity' – NLC.

'Voyager [ST: VOY, 1995-2001]. This show seems to be a high-water mark for the franchise in many ways. By the time Janeway and her crew become lost in the Delta quadrant, the main beats of what makes a great Star Trek story had been hammered out and purged of dross. I also think Janeway is the most compelling captain' – CC.

## Favourite character?

'Captain Picard [from ST: TNG]. But I also loved Janeway and Torres [from ST: VOY]' – SWL.

'It's a almost a tie between Q and Lwaxana Troi [from ST: TNG] – though in the final analysis, I'd have to say Q because of his omnipotence (albeit relative)!' – DM.

'Data from ST: TNG [...] In "Measure of a Man" his status as an individual is put on trial when he is declared a legally autonomous individual, rather than property of Starfleet' – NLC.

## Lost in Orbit: Satellite *Star Trek* Fans
Bianca Spriggs

*Fig. 3: Actor William Shatner, who played Enterprise Captain James T. Kirk in the original Star Trek television series and seven feature films, famously parodied himself in an NBC-TV Saturday Night Live sketch telling a group of obsessed fans to, 'Get a life!' ©WilliamShatner.com (used by permission).*

'I think I'm going to go with Leonard McCoy [from *ST: TOS*]. He's a doctor, not a bricklayer. But if I can't have him on my team, give me Porthos, Captain Archer's beagle [from *Star Trek: Enterprise (ST: ENT)*]. Don't feed him cheese' – CC.

**Favourite romantic hook-up?**

'Uhura and Spock in the recent *Star Trek* reboot. I think it was doubly surprising because it was both shocking and fitting' – SWL.

'Data and Tasha Yar [from *ST: TNG*]' – KM.

'Trip and T'Pol [from *ST: ENT*] were hot and I loved Worf and Jadzia's [from *ST: DS9*] marriage, but the relationship between Dr Crusher and Ronin [from *ST: TNG*] in the "Sub Rosa" [Season 7 Episode 14] episode had me glued to my chair' – DM.

'Jean-Luc Picard and Vash [from *ST: TNG*] who met on the planet Risa in the episode 'Captain's Holiday' [Season 3 Episode 1]. Their romance was brief, but they were most definitely kindred spirits and Vash refers to Picard as her "best love" later in the franchise' – NLC.

'Do you remember that episode in which Tom Paris [from *ST: VOY*] crosses the trans-warp barrier and his DNA begins evolving at a quickened pace? He grows an extra heart, kidnaps Janeway, and takes her across the trans-warp barrier as well, after which they evolve together, land on a planet, hook up, and have super-evolved lizard babies together' – CC.

**Do you prefer a particular medium to experience the franchise? TV? Film? Books?**

'I think that the episodic format is perfect for a weekly show about exploration and humanity. Every episode can be a completely independent experience, viewed entirely on its own, without having to relate back to other episodes or wrap up other storylines as the case may be with other shows. That being said, there is nothing like seeing a good *Star Trek* movie in the theater' – NP.

'TV and Film. I´m better versed in the films with the original cast than the series' – SWL.

'TV. I imagine it like an addict preferring the needle – quick clean delivery' – DM.

'TV. Most definitely. The narrative arcs that they began building into seasons starting with [ST:] TNG offer some of the best stories in television history [...] You can't tell stories this long, with this much depth in any other medium. Well, I guess you could in comics, but I've never read any Star Trek comics – they always seemed written and penciled by second stringers' – CC.

**Have you ever been to a convention or have plans to attend? Why or why not?**

'I have been to the Star Trek Experience in Las Vegas. In fact, I have been a total of six times. [My friend] Chad and I put on our shirts, went down to Quark's Bar, drank an entire fishbowl of rum (called a «Warp Core Breach»), picked a fight with a Klingon, and traded philosophy with a rogue Borg and an Andorian' – NP.

'No. Never been that interested. I find the stereotypical fan base sad and a bit limiting, with the costumes and the Klingon and whatnot. I don´t find anything wrong with the way they choose to access the series, but too often the conversation tends to downplay or criticize the importance of diversity within the franchise as a whole, in favor of a Star Trek world that narrow-minded fans find more accessible. I want to enjoy it without the unnecessary politics of being a Black or female fan' – SWL.

'Yes, although I have only attended two conventions. I wanted to experience that element of the culture as well as to meet the actors who were attending' – KM.

'I've not been yet but as I happen to be in London and all the captains will be at a convention here this October, I may have to go' – DM.

'I definitely have plans to attend a Star Trek stand-alone convention at some point, but I have been to several general fandom conventions and I am always excited to meet other fans' – NLC.

'I've been to comic cons that have had a significant Star Trek showing, but I've never been to any conventions solely dedicated to Star Trek. I would check one out if there was one nearby, but I really don't have any desire to meet cast members or reminisce with near-strangers' – CC.

**Do you prefer to refer to yourself as a 'Trekkie' or 'Trekker'? Why?**

'Neither, but I've always said "Trekkie" and I understand how it's different from being a "Trekker"' – NP.

**Lost in Orbit: Satellite *Star Trek* Fans**
Bianca Spriggs

'I like "Trekker", although I´d never heard it before. It does what the show encourages people to do – pioneer – "boldly go where no one has gone before." I´ve never called myself a "Trekkie", I don´t think. It sounds too static' – SWL.

'"Trekkie." It just seems more natural' – KM.

'"Trekker" because I feel quite knowledgeable about the television/film franchises and I don›t need a costume uniform or prosthetic forehead to demonstrate that knowledge' – DM.

'I usually don't refer to myself as either, since there is a negative stereotype associated with both terms. But I think "Trekkie" has more appeal' – CC.

**Favourite *Star Trek* phrase or quote?**

'"What's the best reason for climbing a mountain? Because it's there." – Kirk'

"I am, have been, and always shall be your friend." – Spock, dying' – NP.

'I love Kirk´s cooking advice from the film series. Beans and bourbon. Dillweed in scrambled eggs. Winning combinations I would not have learned without him' – SWL.

'"I will not sacrifice the *Enterprise*. We've made too many compromises already; too many retreats. They invade our space and we fall back. They assimilate entire worlds and we fall back. Not again. The line must be drawn here!" (Jean-Luc Picard from *ST: TNG*)' – DM.

'"The Prime Directive is not just a set of rules. It is a philosophy, and a very correct one. History has proven again and again that whenever mankind interferes with a less developed civilization, no matter how well intentioned that interference may be, the results are invariably disastrous" – (Jean-Luc Picard from *ST: TNG*, "Symbiosis" [Season 1 Episode 11])' – NLC.

'Spock's line from [*ST2:*] *The Wrath of Kahn* [Nicholas Meyer 1982], after he saves the ship and is dying from radiation poisoning: "I have been, and always shall be, your friend"' – CC.

**If you were immersed in the Star Trek universe, what department would you prefer? Bridge officer/command? Engineering? Medical? Security, etc.?**

'Command, obviously. I wouldn't be suited for anything else' – NP.

'Medical, because you get to interact with much more of the crew than the other departments, not to mention being in charge of the bio-scans for other species and constantly being taken along on away missions! Also, you can override the captain when you feel like it' – DM.

'I'd want to be one of the admirals that are only responsible for hanging out in San Francisco and poking their beer bellies into a scene when someone needs to be disciplined' – CC.

**What do you imagine it must feel like to be 'beamed up'?**

'I bet it's like when your leg falls asleep and it starts to wake up and gets crazy tingly, except all over' – NP.

'Disintegrating into particles and the fear of not knowing how you´ll be put back together again' – SWL.

'A slight dizziness and then a jarring much like the leg jerk that occasionally occurs when you are drifting off to sleep' – KM.

'Like being submerged in champagne' – DM.

**Anything you'd like to add?**

'I was kidnapped by a band of Klingons during my wedding rehearsal' – KM.

'What makes the genre special, what makes *Star Trek* special, is the way it is oriented towards the future' – CC.

Chapter
7

# *Star Trek* Fans as Parody: Fans Mocking Other Fans

## Paul Booth

→ One particular scene in Kyle Newman's film *Fanboys* (2009) sums it up precisely: a group of *Star Wars* (Lucas, 1977-2005) geeks, poised together at the (fictional) birthplace of Captain James T. Kirk in Iowa, taunt and goad the pimply, bespeckled, overweight and elderly fans of *Star Trek* into a fight. The *Star Wars* fans, nerdy in their own right of course, but not nearly as obscenely stereotypical as the Trekkies, besmirch the *Star Trek* name in favour of their beloved text. A fight ensues; the *Star Trek* and *Star Wars* fans collide in a hurried and pitched battle. The *Star Trek* fans hold their own until the *Star Wars* fans retreat to their oversized van.

Fig. 1: *Galaxy Quest was a 1999 cinematic parody of Star Trek and its fans. Image © DreamWorks LLC.*

Although neither the *Star Wars* fans nor the *Star Trek* fans triumph in this fight, there is a clear-cut winner according to the film's narrative: *Star Wars* fans may be geeks, *but at least they're not Trekkies!*

A decade earlier, a similar representation took place in Dean Parisot's film *Galaxy Quest* (1999). Although not naming *Star Trek* specifically as *Fanboys* does, *Galaxy Quest* depicted a parodic version of the show, complete with two groups of fans: the Alien and the Terrestrial. As in *Fanboys*, the *Star Trek* fans in *Galaxy Quest* are nebbish, nerdy, and maladjusted – although they do help save the universe, so at least there's that.

And a decade before that, yet another group of 'Trekkies' was mocked by *Star Trek* actor William Shatner himself in the classic *Saturday Night Live* (Michaels, NBC, 1975-present) 'Get a Life!' sketch (1986). According to fan scholar Henry Jenkins in his canonical *Textual Poachers* (1992), as a distillation of many popular fan stereotypes, this sketch became a concrete representation of the prejudice and antipathy surrounding fans and fan cultures in the 1980s and 1990s. This parody of fandom illustrated common conceptions of fans today: Fans

*Are brainless consumers who will buy anything ...*
*Devote their lives to the cultivation of worthless knowledge ...*
*Place inappropriate importance on devalued cultural material ...*
*Are social misfits who [...] foreclose[ ] other types of social experience ...*
*Are feminized and/or desexualized ...*
*Are infantile, emotionally and intellectually immature ... [and]*
*Are unable to separate fantasy from reality ...*

Scholar Joli Jenson (1992) adds to this list two common representations of fans in

### *Star Trek* Fans as Parody: Fans Mocking Other Fans
Paul Booth

the media: 'the obsessed individual and the hysterical crowd.'

In *Fanboys*, *Galaxy Quest* and 'Get a Life!' then, a number of clear-cut connections can be illustrated: in the nearly three decades since 'Get a Life!' first premiered, the depiction of fans – and *Star Trek* fans especially – has not really changed that much, despite, as Henry Jenkins noted in 2007, the courted presence of fans in the media industry.

With little doubt, Trekkers are the most famous fans of all time: they've had two films made about them (*Trekkies* [Nygard, 1997] and *Trekkies 2* [Nygard, 2004]), they are the de facto fans in terms of intensity and emotional connection to the text, and they continue to be the exemplar par excellence for show-saving letter-writing campaigns, slash-fiction writing ('slash' is even named after the punctuation in the Kirk/Spock fan-fiction) and general obsessive nerdiness. On the famous 'Geek Hierarchy' Internet chart (http://brunching.com/images/geekchartbig.gif), Trekkies are the only science fiction-based group of fans listed by name: no Lucas-freaks, no Whedonheads, no David Ducho-vny Estrogen Brigade. *Star Trek* fans are still the standard bearers of fandom.

Yet, *Star Trek* fans remain the butt of even the most fannish of jokes. *Star Trek* fans are continually pathologized, mocked or ridiculed – despite the fact that fandom itself has become a more accepted mode of spectatorship, as I have previously shown in my book *Digital Fandom* (2010). In fact, in the two decades since Jenkins and Jensen started writing about these negative stereotypes, fandom itself has changed. Thanks in part to the Internet, fans are more visible and active, and thanks to fan scholars, fans are more studied. But many of these stereotypes remain, and many are specifically fo-cused on *Star Trek*. This chapter provides a rationale for why *Star Trek* fans specifically are maligned by analysing the representation of *Star Trek* fans as a *parody* of fannish identity. Through an examination of the representation of *Star Trek* fans in *Fanboys* and in *Galaxy Quest*, I show how fan identity can safely be mocked by setting *Star Trek* fans apart from 'other' fans. These representations actually hide the pathologization of fans beneath the more overt mockery of *Star Trek* fans particularly. It's as if media texts such as *Fanboys* or *Galaxy Quest* are saying 'fans may be nerdy, but we're not *that* nerdy'. There's always someone more crazy than you are in your fandom: media representa-tions of fans seem to argue this point with *Star Trek* fans specifically.

By the end of the chapter, I will have shown that there still appears to be a need for media corporations to mock fans. This need exists despite the fact that, as media schol-ar Roberta Pearson has argued, fans are often 'used' by media corporations to do free labour, especially in this 'web 2.0' world. As I will show, this need may stem from a desire to please two disparate audiences: those that are fans, and those that want nothing to do with fans. Or perhaps this need emerges from a desire to avoid comparisons to those age-old stereotypes. I will show how, in either case, *Star Trek* fans receive the brunt of the negative portrayal.

### Hyperreality and *Fanboys*

For years, fans have been portrayed in the media as miscreants, antisocial loners or just plain crazy. *Star Trek* fans in particular are upheld as an overt and obnoxious type of fan. At the same time, many academic studies of fans have attempted to 'make lemonade from lemons', by showing the activity of fans and the productive nature of fandom (quite rightly, I might add). Fandom and fan activities – things like writing fanfiction, creating fan videos, constructing fan communities, cosplaying (dressing in costume and role playing as characters), gaming, or just chatting about the show with others – make explicit a reading activity that many people do implicitly every time they pick up a novel, turn on the TV, or fire up the video game console. That is, audiences *actively make their own meanings*. Fans externalize this activity by bringing it to the forefront of their fandom, but viewers often internalize and interpret whatever they encounter. If two people watch the same film, they may get very different meanings from it, depending on their background, their culture, or even just their general mood on the day they saw it.

Despite this fact, however, in the past fans have been portrayed as over-the-top, emotionally-stunted viewers. It seems that, in general, there are reasonable ways to be viewers – controlled, rational, distanced – and irrational ways to be viewers – emotional and hyper-intensive. Henry Jenkins (2007) has argued that, as a type of active spectatorship, fandom is becoming a standard mode of media viewership – even if media corporations shy away from the term 'fan' in favour of other, less-contested terms like loyal, prosumer or influencer. As Jenkins says, these terms 'rest on the same social behaviors and emotional commitments that fan scholars have been researching over the past several decades […] [they] are simply a less geeky version of the fan'. Recent attention to this active (and obviously 'fannish') audience can be seen in the way media corporations harness fan work for promotion, for the creation of new products, or in order to gather more viewers.

Just as media corporations have realized that they *need* fans, they also seem to want to distance themselves *from* fans. One way to do this is through a hyperreal depiction of fans, and *Star Trek* fans are perfect for this representation. Twentieth-century philosopher Jean Baudrillard uses the term 'hyperreal' to describe the way one particular representation can overshadow and hide a more insidious representation. In this way, a very obvious stereotype can often hide more subtle – but still viable and troubling – stereotypes. In his massively influential book *Simulacra and Simulation* (1994), Baudrillard uses the example of the Watergate scandal as a hyperreal political moment: we can all point to Watergate as a supreme example of unethical government behaviour, and in doing so we ignore the smaller but no less important moments of government corruption.

This example of hyperreality can be extended into media representations as well. With Brian Ekdale (2011), I have previously written about how the US remake of *The Office* (Daniels, NBC, 2005–2013) creates the character of Dwight as a 'hyperreal' employee – we laugh at how completely he has bought into the capitalist system and manage to

### *Star Trek* Fans as Parody: Fans Mocking Other Fans
Paul Booth

forget that all the others in the office have as well. But hyperreality can be about larger social issues as well. To bring the discussion back to *Star Trek*, take the fact that it has been extraordinarily progressive in representations of race in the future. We can all point to race as a characteristically enlightened aspect of the *Star Trek* philosophy, but in doing so we avoid the fact that there is a lack of diversity in terms of sexual orientation on the show as well. Hyperreality is a characteristic of most media, and can be found within multiple texts, readings and portrayals.

In terms of fandom, the fact that *Star Trek* fans are often portrayed as extremely antisocial in comparison with other fans makes us forget that these other fans are being portrayed stereotypically as well. *Star Trek* fans serve, then, as a hyperreal quarantine of identity. This hyperreal portrayal serves to protect and sequester 'fannishness', both preserving and mocking the fannish identity. In other words, *Star Trek* fans are represented in the media as over-the-top precisely to *hide* the pathologization of other fans that media enact.

We can see this in *Fanboys* most dramatically. In the scene previously discussed, the *Star Trek* fans are the obvious mockery; but this doesn't change the fact (although it does obscure it) that the *Star Wars* fans are also rather negatively portrayed. The most hardcore *Star Wars* fan, Hutch, is the standard-issue representation of fans: overweight, living in his family's garage, obsessed with minute details of *Star Wars*, and overbearing with his emphatic love of the franchise. These are typical negative stereotypes of fans in the media, which Joli Jensen identifies as 'excessive, bordering on deranged'. Although the characteristics of obsessiveness, obtuse caring and emotional attachment are not necessarily negative in general, the film *Fanboys* relies on these stereotypes for humorous effect.

Similar stereotypes pepper the other fans in *Fanboys* as well. Each time the *Star Trek* fans take the *brunt* of the stereotype but this only serves as a hyperreal veneer that hides the pathologization of the *Star Wars* fans as well. The *Star Trek* fans are pimpled, obsessive, obese and speak in Klingon. Hutch's friends are also extreme *Star Wars* fans, so much so that they have constructed a map to George Lucas's Skywalker Ranch and intend to watch *Episode I* before it is released. Their cross-country adventure demonstrates an obsessiveness to their fandom, a clear case of fans who, in the words of Henry Jenkins, 'place inappropriate importance on devalued cultural material [...] [and] are social misfits who [...] foreclose[] other types of social experience' (1992).

Even when they end up in Las Vegas and Hutch and Windows find themselves at the receiving end of some sexual attention, their immaturity shines through, as does their inability to recognize prostitutes. It's not that they aren't sexual; it's that their sexuality is limited to childish and immature experiences, such as their earlier homophobic reaction to being forced to perform a striptease. Windows, as a case in point, is mocked by

his friends for having an online romance. The romance is then further mocked by the audience when it turns out the romantic partner was (unbeknownst to him) a 10-year-old girl.

Although the movie makes it clear that these *Star Wars* friends *are* geeks, they are most definitely not considered as geeky as their *Star Trek* counterparts. And in this, the film makes it OK to make fun of the stereotypes of *Star Trek* fans, but not their Lucasfilm counterparts.

### Parody and *Galaxy Quest*

Using a similar thesis of hyperreality as does *Fanboys* (although it came out ten years earlier), the film *Galaxy Quest* clearly represents media fans as a way of subtly mocking *Star Trek* fans. In *Galaxy Quest*, however, the method of hyperreality is more complex, and invokes an element of parody as well to further differentiate the 'good' fans from the 'bad'.

Specifically, the parody of *Galaxy Quest* works in two separate but connected ways. First, the entire film works as a parody of the role *Star Trek* has played in our culture. Second, the specific representation of fans within the film enacts a parody of fandom through the representation of the alien race, the Thermians, whose fanaticism and cultural detachment prevents their understanding the difference between reality and cultural artefact.

Parody works because it both subverts and supports the system that it parodies. That is, one has to necessarily use enough of the parodied material in order to make the parody obvious, but because the parody must mock the system as well, it must subvert the characteristics that it upholds. In its own way, parody works similarly to hyperreality – it's just more open about the mockery it undertakes.

I want to focus on how the Thermians in *Galaxy Quest* enact a parodic view of fandom in a way that lets the audience skim over stereotypes within the hyperreal depiction of the *other* fans of *Galaxy Quest*, the human fans. That is, because the audience has been presented with a laughable and parodic version of fans in the guise of these alien visitors, we tend to forget the other stereotypes presented in the film.

The similarities between *Galaxy Quest* and *Star Trek* are more than superficial. The film depicts an underrated but much-loved cult media franchise called *Galaxy Quest* which aired on television for a number of years in the past and whose now-aging stars have to deal with typecasting and the fans who besiege them. On the convention circuit, these actors are inundated with fan questions while also dealing with the hubris of the William Shatner-esque lead, Jason Nesmith. During one convention, the Thermians kidnap the stars. For years, the aliens have watched the episodes of *Galaxy Quest* whose broadcasts went beyond their intended Earth-bound audiences, have thought they were actual historical documents, and have thus mistaken fiction for fact. Because of the morality and 'happily ever after' nature of the episodic structure, the Thermians

## *Star Trek* Fans as Parody: Fans Mocking Other Fans
Paul Booth

have based their entire civilization on these historic documents.

Specifically, the Thermians articulate the most extreme version of fan stereotypes – not only are they socially-inept, but they have completely misrepresented the nature of the media text. Like the description of fans Jenkins notes in his original 1992 analysis of the 'Get a Life!' sketch, these Thermians seem almost psychologically damaged by their insistence on the 'reality' of the fiction. Their commitment to the believability of the show goes so deep as to allow them to build complete working spaceships based on the original film: a monumental achievement. *Star Trek* fans similarly create monumental projects, like the famous 'New Voyages' team that imagined the original *Star Trek* (1966–1969) series' last two years of its 'five-year mission'. The Thermians' appearance and traits – pasty white skin, nervous and skittish mannerisms, social awkwardness – seem to be closely modelled on stereotypical fan characteristics.

Of course, this isn't to say that the Thermians are *bad people* – merely that in the context of the movie they are depicted as overt caricatures of the classic media representation of the fan. That they end up triumphing over the evil Sarris is a testament to their commitment to the ideals of the show, not necessarily their own personal identities. And in making such an overt representation of fans, the film *Galaxy Quest* manages to skim over and elide the representation of another group of fans with equal stereotypical characteristics: the human fans, most saliently personified in Brandon.

Brandon is a young man who lives at home with his parents and is obsessed with *Galaxy Quest*. He remains stalwart in his defence of the show to his parents and friends, and even defends Nesmith's bad behaviour. With his friends, Brandon attends the convention at which he meets Nesmith, and becomes embroiled in the Thermian's adventure when he accidentally swaps his fake communicator with their identical-looking but functional model. In the comedic highlight of the film, Nesmith calls Brandon on the communicator to aid in the safe piloting of the Thermian ship. When Brandon answers, he offers to Nesmith that he is completely aware the show is fictional. Nesmith interrupts the boy: 'Stop for a second, stop. It's all real.' Brandon responds, ecstatically, 'Oh my God, I knew it. I knew it! I knew it!': clearly, like the Thermians, he is also 'unable to separate fantasy from reality', to put it in Jenkins' terms. But we don't see his representation as negative because we spend so much time laughing at the Thermians (and also, perhaps, because it is crucial to the resolution of Thermians' crisis).

Brandon's representation as a fan seems less pronounced than the representation of the Thermians, but this doesn't mean it isn't negative. In Jensen's terms, he appears to be the 'lone fan' while the Thermians are the 'hysterical crowd'. By providing a context around which fans can be identified, *Galaxy Quest* and *Fanboys* both use extreme examples to hide similar, if not as radical, stereotypes of fans.

### Conclusion
But why is this important? Why does it matter that fans are mocked in these hyperreal,

parodic ways?

Part of the reason this is important is because it's so insidious. It's easy to laugh at stereotypes – especially when they're of us – but it's problematic to think that *all* fans act in this manner. By singling out an extreme portrayal, the media reinforce negative stereotypes without creating positive images to replace them with.

But the main reason it's important is because these media texts make us *think* that the less-negative stereotypes (the *Star Wars* fans in *Fanboys*, the human fans in *Galaxy Quest*) are positive simply by comparison to the *obviously* negative stereotypes. This representation may seem less negative, which makes us accept it uncritically. But because it actually is negative, we not only *have* accepted it, we *perpetuate* it by believing it to be positive.

By reinforcing these negative stereotypes, even through our own uncritical acceptance of them, we end up subconsciously maintaining the same representations that have always plagued fans. Faced with these representations, fewer people may admit to being fans for fear of being labelled 'brainless ... worthless ... inappropriate ... desexualized ... infantile ... social misfits who ... are unable to separate fantasy from reality'. And no one should have to hide who he or she is.

Perhaps, then, the people who need to 'Get a Life' today are those who artificially separate types of fans into good/bad, socially acceptable/unacceptable, or just plain sane/crazy. *Star Trek* fans may be upheld as paragons of fandom: but they should be respected, not faulted, for it. ●

## GO FURTHER

### Books

*Digital Fandom: New Media Studies*
Paul Booth
(New York: Peter Lang, 2010)

*Living with* Star Trek: *American Culture and the* Star Trek *Universe*
Lincoln Geraghty
(London: I.B. Tauris, 2007)

*Fan Fiction and Fan Communities in the Age of the Internet*
Karen Hellekson and Kristina Busse (eds)
(Jefferson, NC: McFarland Pub, 2006)

*Simulacra and Simulations*

## *Star Trek* Fans as Parody: Fans Mocking Other Fans
Paul Booth

Jean Baudrillard, trans. Sheila F. Glaser
(Ann Arbor, MI: University of Michigan, 1994)

*Textual Poachers: Television Fans and Participatory Culture*
Henry Jenkins
(New York: Routledge, 1992)

### Extracts/Essays/Articles

'Translating the Hyperreal (Or How *The Office* Came to America, Made Us Laugh, and Tricked Us into Accepting Hegemonic Bureaucracy)'
Paul Booth and Brian Ekdale
In Carlen Lavigne and Heather Marcovitch (eds). *American Remakes of British Television: Transformations and Mistranslations* (Lanham, MD: Lexington Books, 2011), pp. 193–210.

'Fandom in the Digital Era'
Roberta Pearson
In *Popular Communication*. 8: 1 (2010), pp. 84–95.

'Fandom Squared: Web 2.0 and Fannish Production'
Jeff Watson
In *Transformative Works and Cultures*. 5 (2010), doi:10.3983/twc.2010.0218.

'The Future of Fandom'
Henry Jenkins
In Jonathan Gray, Cornel Sandvoss and C. Lee Harrington (eds). *Fandom: Identities and Communities in a Mediated World* (New York: New York University Press, 2007), pp. 357–64.

'Fandom as Pathology: The Consequences of Characterization'
Joli Jensen
In Lisa A. Lewis (ed.). *The Adoring Audience* (New York: Routledge, 1992), pp. 9–29.

### Films

*Fanboys*, Kyle Newman, dir. (Los Angeles, CA: The Weinstein Company, 2009)
*Galaxy Quest*, Dean Parisot, dir. (Los Angeles, CA: DreamWorks SKG, 1999)

# ONE OF THE ADVANTAGES OF BEING A CAPTAIN, DOCTOR, IS BEING ABLE TO ASK FOR ADVICE WITHOUT NECESSARILY HAVING TO TAKE IT.

**CAPTAIN JAMES T. KIRK**
STAR TREK: THE ORIGINAL SERIES
SEASON ONE, DAGGER OF THE MIND

Chapter
8

# Lieutenant Sulu's Facebook: 'Professor' Takei and the Social Networking Classroom

Nathan Thompson and Kenneth Huynh

→ **Growing up in California, it was illegal for Asians to marry whites. How times have changed. I married a white DUDE. And an adorable one, too!**
George Takei, on his Facebook page

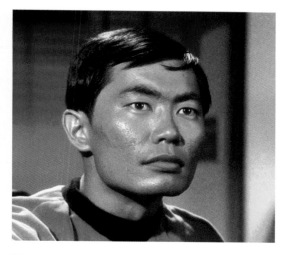

Fig. 1: Actor George Takei as Lt. Hikaru Sulu on Star Trek in 1966. Image © Paramount Pictures.

As an older Asian gay man, George Takei's popularity on Facebook may seem a bit of a puzzle. He is most recognized for his role as Lieutenant Hikaru Sulu from *Star Trek: The Original Series* (*ST: TOS*), which aired 1966-1969 – but the majority of his Facebook fans were born sometime after 1977. He started a Facebook page to communicate with fans back in March of 2011. The page has over 1.8 million followers (as of 12 May 2012) and is growing from between 40 and 150,000 followers a week. Even rapper Eminem, the most liked person on Facebook, doesn't hold an advantage over Takei when it comes to engagement. While Eminem has just over 57 million followers (55 million more than Takei) his posts receive about the same number of likes, shares and comments.

One possible reason for Takei's popularity on Facebook is his use of Internet 'memes'. Jean Burgess, in her 2008 exploration of viral videos and participatory Internet culture, describes the contemporary usage of the term 'meme' as 'a faddish joke or practice (like a humorous way of captioning cat pictures) that becomes widely imitated'. Takei's Facebook page is dominated by a wide variety of sci-fi and pop culture-referencing Internet memes, primarily in the form of humorous pictures that have been replicated, imitated and/or modified via other sources on the Internet.

Facebook is an ideal place for the proliferation of such images since all one has to do is click 'share' on a particular meme in order for it to be visible to the rest of one's network. Takei is excellent at posting memes to Facebook, which are then shared by many of his fans. These fans then follow suit by sharing the photo to their networks, which in turn gives Takei more visibility and more followers. While Takei's posts are predominantly lumped into the category of 'memes', he also occasionally posts on his political involvements with sexual and racial minority groups. For example, he often posts regarding the 'It's OK to be Takei' campaign, which originated on Facebook in reaction to Tennessee lawmakers trying to pass the so-called 'Don't Say Gay' bill. Takei also is the Chairman Emeritus of the Board of Trustees for the Japanese American National Museum in Los Angeles, California, and has posted about the Japanese-American internment camps of World War II.

Those who think of Facebook probably do not automatically think of it as a platform for political debate. However, Aaron Smith and Lee Rainie, in their report on the Internet and the 2008 US election, found that social networking sites are increasing in importance as places from which to gather political information. Matthew Kushin and Kelin Kitchener, in their 2009 exploration of social networking sites as places for online

## Lieutenant Sulu's Facebook:
### 'Professor' Takei and the Social Networking Classroom
Nathan Thompson and Kenneth Huynh

political discussion, found that when political discussions do occur on social network-ing sites, they often present few opposing views because people tend to network with like-minded individuals. But what happens when someone like Takei brings together a group of people based, not on shared friend networks, but on a shared love of popular sci-fi culture and humorous photos? Our chapter attempts to offer one answer to this question by exploring Takei's use of Facebook as a place for Internet humour *and* anti-oppressive education. We will discuss a sampling of posts from Takei's Facebook page that focus on issues of race and sexuality. We then discuss the use of these posts as both a means to draw in a large audience and as a way to teach anti-oppressive education.

### 'The best helmsman in the galaxy': Takei and his fans on race
Takei effectively utilizes the two aforementioned strategies to discuss racial stereo-types and conflicts prevalent to the United States' past and present context. That is, he uses humorous memes that critique and satirize prevalent racial stereotypes, and long-er and more measured written content to discuss current and more politically charged events and issues. While invariably interrelated, race as a topic of discussion is less often discussed by Takei than is sexuality. Based on our observations, posts that spoke to con-versations about race and racism were more sporadic and spaced out.

Generally speaking, Takei's audience responds well to his attempts to make evident his own viewpoints on popularly-known racial stereotypes with memes and posts. They respond with either appreciation/laughter or by offering a light-hearted, likeminded retort to his critique. For example, on 19 October 2011 he addressed the widespread per-ception that Asians are 'bad', reckless, careless and unskilled drivers. Takei wrote: 'I tell young people today, I broke that Asian driver stereotype decades ago by being the best helmsman in the galaxy' (4,103 likes, 206 comments, 291 shares). The majority of his au-dience enjoyed both the joke, with its reference to his role on *ST: TOS*, as well as Takei's critique, a typical response being 'lol' or 'Right on, George'. Another made an attempt at humour, refuting Takei's statement with this statement:

Nothing but love for you George, but unfortunately it wasn't quite enough since a lot of people in the greater Seattle area reinforcing that particular stereotype. They do make up for it with a ton of really good pho restaurants ...

Perhaps tellingly, the fan's statement was met with silence, indicating either the au-dience's indifference to the statement, or its acceptance, based on the light-hearted terms of engagement set by Takei.

Indeed, it could be argued that there is a certain amount of baseline sensitivity and sophistication among Takei's fans. Between the years 1942 and 1945, the US govern-ment, fuelled by racist paranoia, forcibly placed all people of Japanese descent in in-ternment camps, for fear that they were co-conspirators with the Imperial Japanese

government. Takei himself lived in these camps during his childhood. On 19 February 2012 he made reference to this on his Facebook page and most of his audience seemed mindful, respectful and deferent by expressing sympathy and solidarity with Takei (5,406 likes, 488 comments, 1,117 shares). One said:

George, I am so so sorry this happened to you. It brought tears to my eyes. NO ONE should have to endure anything like that simply because of the way they look. If I could hug you, I would and I would tell you I am sorry for the childhood you were robbed of, the horror your family had to see and the ignorance of a President. With love, Lauren xoxo

Race, however, in particular instances, is a controversial topic for his audience. Trayvon Martin was a 16-year-old African American who was shot and killed in an affluent Florida neighbourhood in February 2012. The shooter was George Zimmerman, a neighbourhood watch captain of white and Latino descent. The case galvanized racial tensions in the United States, resulting in several weeks of widespread media coverage, debate, protest and the threat of violence. In response, Takei wrote a blog post on 25 March 2012 condemning the actions of Zimmerman and demanding he be brought to justice (5,944 likes, 1,745 comments, 1,324 shares). Response to Takei varied, ranging from those who praised and supported his work, to posts that were violently racist. For instance, one commenter wrote:

Of course they call for revenge. It's all they have. As more and more facts keep coming out suggesting that [Trayvon] wasn't quite the innocent little sweetheart the media is making him out to be, more witnesses, more 911 records, all they're going to have left is inciting violence in 'revenge' for what could very well end up being a legal self-defense shooting. (And more attacking random white people ... but that ain't racist when they do it.)

Interestingly, and reflective of a general awareness of racism and capacity, comments like that are quickly criticized by some of Takei's other fans. While Takei is silent, others are not. An overview of the posts reveal an immediately apparent back-and-forth dynamic, wherein the issue of race and racism is hotly debated. Indicative of this dynamic is this typical exchange:

Jesus some of you people are stupid, Takei especially for writing this drivel. Why was the kid suspended for 5 days? Why was he on top? Why did the idiot get out of his car to confront him? Lots of stupid on both sides, but the one thing that is 100% certain is that it's not murder. That requires intent [...]

Another immediately responded: 'George: Please ignore all the wankery. Thank you for this blog post.'

## Lieutenant Sulu's Facebook:
### 'Professor' Takei and the Social Networking Classroom
Nathan Thompson and Kenneth Huynh

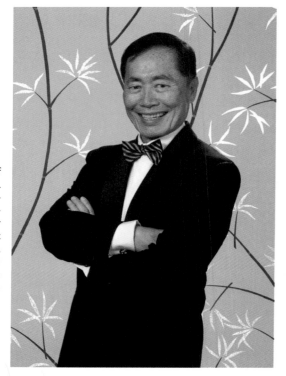

*Fig. 2: George Takei has used his fame as a gay man and Star Trek cast member to draw attention to issues like the bullying of LGBTQ teens. Image © CBS Studies, Inc.*

### 'That's so Takei': Lieutenant Sulu and sexuality

As mentioned in our previous section, the majority of Takei's Facebook posts are centred on issues of sexuality. Takei often posts photographs that lampoon and re-imagine his role on *ST: TOS* in order to discuss issues of sexuality. While Takei has played numerous characters on other well-known television series, the character of Lieutenant Sulu has now become enshrined by *Star Trek* fan culture, a fan culture so unique and thriving it even has been called religious by Michael Jindra in his 1994 article on *Star Trek* fandom. So Takei's use of Sulu as a vessel to joke about his sexuality comes as no surprise.

In one telling photograph, Sulu is seen talking to the *Enterprise*'s Communications Officer, Lieutenant Uhura. The speech bubble beside Uhura reads, 'The captain kisses like a girl' to which Sulu replies, 'I know' (4,216 likes, 281 comments, 1,301 shares). Although the episode to which Takei's post alludes ('Mirror, Mirror,' Season 2, Episode 4) takes place in an alternate universe, the message still remains the same: Sulu has kissed Captain James T. Kirk. Takei posted the image as his Facebook cover photo (a banner image that remains at the top of a Facebook profile) on 7 March 2012 and it remained there for one week. In other words, if you visited Takei's page during that week there would be no way you could miss it!

In another photograph posted 8 March 2012, Kirk is seen struggling with an alien species known as 'The Gorn' ('Arena,' Season 1, Episode 18). The Gorn's speech bubble says, 'I heard you kiss like a girl …' while Kirk's thought bubble says, 'Damn you Sulu !!!!!' (15,583 likes, 1,078 comments, 3,280 shares). While Sulu is not physically present in the photograph, the assumed takeaway message is that Kirk and Sulu have kissed.

While both of these photos make direct reference to Sulu's presumed homosexuality (and therefore Kirk's by association) they did not seem to receive any negative feedback from Takei's large Facebook fan base. The comments were light-hearted and humorous. Some examples include:

OMGOSH!!!!!TOOFUNNY!!!!
Thanks for the posting of this one George. Absolute Riot!!!
Background music: Lady Gaga's 'Gorn This Way' [An obvious reference to Lady Gaga's 2011 hit LGBTQ-themed song 'Born This Way'.]

From these comments, one would assume that Takei's Facebook fans are comfort-

able with his 'out' status as a gay man and with his creative take on the role of Sulu in *ST: TOS*. However, if we take a look at Takei's more politically-charged posts, it is evident that not all of his fans are accepting.

On 5 March 2012, Takei posted a picture of his husband and himself at a red carpet event with a caption that reads:

Had a great few days of appearances and performances, including on '8' with a terrific cast (raising money for the American Foundation for Equal Rights), in Broadway Back-wards, where I was the coach of a lesbian softball team (raising money for Broadway Cares/Equity Fights AIDS) and even on *Ellen*. Here's me and my husband Brad Takei (yes, he took my name!) on the Red Carpet before '8'. (8,315 likes, 934 comments, 150 shares).

While the post itself seems rather mundane in nature, there were those who expressed reservations. For instance:

'I will always like you as a person George ... never the lifestyle you chose.'
'Can't he ever talk about anything besides being gay.'
'Just don't plan to make it to Heaven. The world may change, but God's word does not!'

The majority of the comments directed towards Takei were positive, but the addition of the dissenting comments (tellingly, not found on Takei's more humorous posts) indicate some resistance. Takei's referencing of LGBTQ-themed events, equal rights organizations and his husband signify a political activism that is much more overt than the homoerotic posts depicting Sulu and Kirk as potential sexual partners. Takei has an opinion and he's not afraid to share it with his Facebook followers, but some of his fans think he takes things too far.

On 21 March 2012, Takei posted a comment in response to remarks made by fellow actor Kirk Cameron, who had just commented on CNN's *Piers Morgan Tonight* that he thought homosexuality was 'unnatural' and that he did not support same-sex marriage. Takei wrote, 'Kirk Cameron was surprised that gay people took offense to his statement that homosexual is "unnatural" and "detrimental to society", reminding us that he has in fact been a consistent idiot all of his life' (72,342 likes, 5,289 comments, 2,938 shares). Many of Takei's fans did not agree with Cameron's perspective as shared on CNN; but they also did not like Takei's use of the word 'idiot' to describe Cameron:

'Way to go, George. Name calling, that's courageous.'
'I think George Takei if he isn't above this sort of thing [...] should be. Buck up buddeh and stop reacting to something you only posted to get Attention.'
'The man was asked his opinion on gay marriage and he gave it. He was respectful about

### Lieutenant Sulu's Facebook:
### 'Professor' Takei and the Social Networking Classroom
Nathan Thompson and Kenneth Huynh

it. People do not have to agree with him on it, but Mr Takei is out of line on this. Respect is a two way street Mr Takei, please remember this as you are posting such rude comments.'

Because Cameron's views are rooted in Christianity and Cameron is a well-known evangelical Christian, comments on Takei's initial post became a conversation between those who advocated a traditional conservative Christian perspective on homosexuality and those who disagreed with it. Some comments from those who were religious and disagreed with Takei included:

'The truth is that Cameron, as is any evangelical Christian (i.e., someone who believes the Truth of Scripture), recognizes a standard which is beyond your understanding, as would likewise be beyond my own understanding were it not for the grace of God. In His Word, God declares that any type of same-sex erogenous union is against what He has decreed to be pure and right. As such, the gay agenda is, at its core, unnatural … and against what has been ordained […] One day, you will understand. I can only hope you will see the Truth before that day comes.'
'I totally agree with kirk!!! I think its against nature and an abomination hate the sin love the sinner its between you and God.'
'Kirk is right. I still like George as an actor, but I don't think that is high on God's list of things He likes.'

Three weeks later Takei posted a video that again referenced the comments made by Cameron. The video was produced by a group called CCOCK (Child Celebrities Opposing Kirk Cameron) and it showed a number of now-grown-up child celebrities making fun of Cameron. The caption of Takei's Facebook post read, 'Kirk Cameron, your peers have answered you' (14,985 likes, 1,688 comments, 5,735 shares). As was the case with the previous post on Cameron, there were a number of comments from Takei's fans that expressed disappointment with Takei:

'oh sorry I didn't know gays were the only ones allowed to express an opinion! Jackass.'
'Mr George Takei you sure have a hard on for dissing Mr Kirk Cmaeron. Why is that? Just because you guys disagree on gay marriage? Is that all? Let me guess you invited him to a party or your home or bed and he politely (sp) refused you because he's not gay. I know I know I went to far. God bless America and the Freedom of speech.'
'Mr. Takei, though we love you, this is shameful. You are perpetuating the same hypocristy and hatred as that to which you opposed. You have let me down today.'
'Very sad indeed.'

While Takei references homosexuality in all of the posts above, the respective posts' consequent comments are very different in tone. Takei's humorous photos referenc-

ing *ST: TOS* and Sulu's sexuality did not lead to a debate between anti-gay and pro-gay supporters. However, posts more serious in nature and that dealt with real-life conse-quences of the marginalization of LGBTQ people in the United States became political-ly and religiously charged, resulting in derogatory comments and insults being directed towards Takei's perspectives and his person.

### Professor Takei's upsetting and uncomfortable classroom

The 'strategy' of attracting a large number of Facebook followers by effectively utiliz-ing Internet meme culture gives Takei access to almost two million people who do not all share similar opinions on the topics of race and sexuality. But as any new follower quickly finds out, he doesn't just post memes: there also is political activism. As the preceding sections have shown, once a post takes a turn away from the humorous, and becomes more 'political', the comments become emotionally charged, and heated de-bates often arise.

We want to suggest that these interactions among Takei and his fans can be thought of as teaching and educational interactions – or more concisely, pedagogical interac-tions. Conversely, these pedagogical interactions can be thought of as uncomfortable or discomforting interactions. They are uncomfortable because for the learner(s) – in this instance, Takei's fans – previous conceptions are troubled and challenged.

Renowned anti-oppression educator and researcher Kevin Kumashiro argues that moments of discomfort are necessary and inevitable in changing individuals' perspec-tives. He states in his 2002 article that, 'repeating what is already learned can be com-forting and therefore desirable; students' learning things that question their knowledge and identities can be emotionally upsetting'. Similarly, a chapter written by Megan Boler and Michalinos Zemblyas for a 2003 book on rethinking educational practices advo-cates a 'pedagogy of discomfort' – one where ideas of social difference are taught by way of uncomfortable interactions.

By evoking upsetting and uncomfortable emotions in some of his fans, Takei thus instigates the formation of a pedagogical space, one driven by the principles of anti-op-pressive education as described by Kumashiro. First, by posting anti-racist and LGBTQ-friendly posts to his Facebook page, he creates a safe space for racial and sexual dif-ference. He also teaches racialized and LGBTQ fans more about their own histories of oppression and marginalization by way of increasing their historical and political aware-ness. Second, beyond speaking to his racialized and LGBTQ fans, his page also provides a platform for him to teach to the privileged (in this case, non-Asian, non-racialized and/ or heterosexual people) about issues of racial and sexual difference.

Crucially, while Takei's post initializes the space, both he and his fans maintain it. Takei does not always respond to the 'fans in crisis' in the comment threads, but fans who share a similar political and social approach often do. These 'co-facilitators', so to speak, often encourage discomfort by questioning more conservative assumptions or

## Lieutenant Sulu's Facebook:
### 'Professor' Takei and the Social Networking Classroom
Nathan Thompson and Kenneth Huynh

by directly challenging these assumptions by way of textual quotes, statistics or facts. In essence, 'Professor' Takei has created an online anti-oppressive classroom in which he delivers a 'lesson' by way of his posts, which are consequently discussed by his fans, or 'students'.

It is important to reiterate the sheer expansive potential of Takei's lessons. We cannot track how far the information provided on Takei's page is disseminated. We cannot track how many times a post has been shared and subsequently shared again. The speculative pedagogical impact of having a political or social message shared exponentially (one share leads to five shares leads to 25 shares, etc.) is mind-boggling.

## Conclusion
For Takei, Facebook is a pedagogical tool to be used to educate people about uncomfortable issues around sexuality and race. In fact, you do not have to take our word for it. In response to the negative comments he was receiving on one of the Kirk Cameron posts, Takei himself wrote:

Actually, if you disagree with me on my stance on gay rights, please do NOT remove yourself from this page. You are the fans I hope someday to reach, on the faith that people are fundamentally good and do want equality for everyone. Each day someone new tells me that they once thought of gay people as abominations or unnatural, but through getting to know gay co-workers, friends or sometimes family members, or even listening to me on Howard Stern or on this page, their opinions changed. I often raise the hurtful or harmful messaging of certain celebrities or politicians on this site as a way to point out that LGBT people are constantly challenged on the very fundamental nature of their humanity and right to participate as equal members of society. In my view, such positions should be criticized, and represent bigotry wrapped in religious doctrine. It reinforces existing prejudice and discrimination and has no place in a civil society, nor does any such speech directed toward religious, ethnic or sexual minorities. So thank you being part of the discussion, and I do hope that you read through the comments here and take many of them to heart.

While it might be easier for 'Professor' Takei to teach only those predisposed to the lesson, the real value is in changing the minds (and lives) of the uninformed or the hostile. ●

~~~~~~~~~~~~~

GO FURTHER

Extracts/Essays/Articles

'"All your chocolate rain are belong to us?": Viral video, YouTube and the dynamics of participatory culture'
Jean Burgess
In Geert Lovink and Sabine Niederer (eds). *Video Vortex Reader: Responses to YouTube* (Amsterdam: Institute of Network Cultures, 2008), pp. 101–09.

'Discomforting truths: The emotional terrain of understanding difference'
Megan Boler and Michalinos Zemblyas
In Peter Trifonas (ed.). *Pedagogies of difference: Rethinking education for social change*
(New York: RoutledgeFalmer, 2003), pp. 110–36.
'Against repetition: Addressing resistance to anti-oppressive change in the practice of learning, teaching, supervising, and researching'
Kevin Kumashiro
In *Harvard Educational Review*. 72: 1 (2002), pp. 67–92.

'Toward a theory of anti-oppressive education'
Kevin Kumashiro
In *Review of Educational Research*. 70: 1 (2000), pp. 25–53.

'*Star Trek* fandom as a religious phenomenon'
Michael Jindra
In *Sociology of Religion*. 55: 1 (1994), pp. 27–51.

Online

'Getting political on social network sites: Exploring online political discourse on Facebook'
Matthew Kushin and Kelin Kitchener
In *First Monday*. 14: 11 (2009), http://firstmonday.org/article/view/2645/2350

'The Internet and the 2008 election'
Aaron Smith and Lee Rainie
Pew Internet & American Life Project. 15 June 2008, http://www.pewinternet.org/Reports/2008/The-Internet-and-the-2008-election.aspx

Chapter
9

The Borg:
Fan Pariah or
Cultural Pillar?

Charles Evans Jones, Jr

→ In 1981 George Orwell writes in his acclaimed novel *1984* (1949): 'We do not destroy our enemies, we merely change them.' Much of this credo rings true for the characters in *Star Trek: The Next Generation* (hereafter *ST: TNG*, 1987-1994), both the protagonist United Federation of Planets and their reoccurring antagonists, the Borg. The former, referred to more succinctly simply as the Federation – a voluntary interstellar union comprising hundreds of alien governments and its paramilitary scientific exploration task force known as Starfleet Command, according to the *Star Trek Encyclopedia* (1997) - travels throughout the galaxy with the intent of seeking out new life and learning as much as possible about those they encounter, all the while propagating their human-centric values.

Fig. 1: A Borg vessel, first encountered in Star Trek: The Next Generation. Image © Paramount Pictures.

The latter, a collectivist cybernetic alien civilization and a literary foil of the protagonists, traverse the universe with similar aims. Much like the Federation, the Borg seek out new life, along with any relevant or useful technology, through an invasive procedure known as 'assimilation'.

During assimilation, individuality becomes stripped, the body becomes augmented with mechanical implants, and the mind becomes integrated into a larger collective consciousness. Assimilation aims to do two things: add the biological and technological distinctiveness of chosen individuals to the Borg collective and to bring harmony to the chaotic existence of the universe. As a result, both the Borg and the Federation do as Orwell says: change their enemies either by indoctrinating them to espouse human-centric values or by forcefully assimilating them with technology. Of the two, only one faction has been grossly misunderstood: the Borg. Despite appearing 31 times in *Star Trek*'s television series and movies, the Borg remain an enigma. However, judging from these appearances it is safe to say that the Borg are no ordinary evil. They are in fact textured, complex and operate by an oft-unarticulated moral philosophy.

With the above mentioned preface in mind, the following chapter argues that the Borg's practice of assimilation is a result of their moderate act-consequentialist (MAC) moral philosophy. In order to demonstrate the MAC roots in the assimilation process and argue that Borg fandom is a result of this moral philosophy, will examine the episode 'I, Borg' (Episode 23 Season 5). The reason for choosing it from among the Borg's other appearances is that it is one of the earliest attempts in the *Star Trek* franchise to question the pure evilness of the Borg's one-dimensional stereotype. The episode also poses the question of whether or not the Borg warrant total annihilation at the hands of the Federation. In this episode, two themes stand out: respect for sentience and the humanization of the alien 'other'. The chapter concludes that fan loyalty to the infamous villains, evidenced by fervent discussions in online fan forums, indicates a basic understanding of the larger moral undertones of Borg assimilation and provides an overall, not to mention refreshing, rationale for fandom.

Philosophy and fandom

According to David Brink (2006), a moderate consequentialist promotes the values

The Borg: Fan Pariah or Cultural Pillar?
Charles Evans Jones, Jr

of others but in limited scope or weight. Moderate consequentialists show concern to those who have the potential to benefit from such an interaction. *The Blackwell Dictionary of Western Philosophy* (2004) says of this philosophy that a 'right' action is one that produces a better consequence than the alternative actions available to an agent. What is more, as Brink contends in 'Some forms and limits of consequentialism', the agent is obligated to be concerned only with those who can benefit from their actions. The Borg's moral philosophy fundamentally conflicts with the Federation's Kantian virtue ethics which, according to Russ Shafer-Landau's *The Fundamentals of Ethics* (2011), holds that an action is right, not because of the results, but because it is done by a virtuous person. In accordance with Kant's moral philosophy, as recounted by the Rachels in *The Elements of Moral Philosophy* (2012), the Federation's virtuousness stems from the belief that all humanoids and non-humanoids are intrinsically valuable and deserve to be treated as free rational agents, not as means to various ends.

The Borg exhibit qualities of act-consequentialists because they view assimilation as intrinsically valuable. Assimilation from the Borg's perspective is the best option when striving to achieve their goals. Simultaneously the Borg are also moderate consequentialists because they limit their concern to only those worth assimilating, namely those that add to their collective's unique capabilities and intergalactic harmony. This particular perspective represents a new line of thought amongst scholars and fans who tend to attribute the Borg's popularity to other factors, such as the species' provocative commentary on technology, gender, race/ethnicity, politics and ethics.

For instance, Diana M. A. Relke argues in her book *Drones, Clones, and Alpha Babes* (2006) that the Borg provide salient commentary on the current state of humanity, namely that it is in a transhuman state. An intellectual movement, transhumanism argues that humanity is in a transitional stage of evolutionary development in which biology becomes vestigial and eventually transcended. Other scholars who have studied the Borg find them compelling both for their 'otheredness' and for the morality they represent. Christine Wertheim, writing in *Aliens R Us: The Other in Science Fiction Cinema* (2002), associates the Borg's collective nature with ethnic 'others' such as Asian and Muslim cultures. Michael C. Pounds, author of *Race in Space* (1999), views the marginalized ethnic status of the Borg in the *Star Trek* universe as the source of their popularity with fans. He frames the fictional aliens as an 'other' on the basis of their moral philosophy. As we shall see, the major argument against the species in the 'I, Borg' episode is that their existence is an attack on the Federation's way of life and thus warrants total eradication. Such a critical stance against this cybernetic collective is symbolic of the Borg's role as moral outliers in the *Trek* realm. In his 2001 article, 'The moral significance of collective entities', Keith Graham argues that collective entities like corporations and the Borg warrant moral consideration on two grounds: the fact that they can be moral agents with benevolent aims, and that they have the potential to be moral patients, that is, victims of deception, cruelty and shame, and consequently

benefactors of generosity and loyalty. As such, collectives like the Borg can be treated both kindly and cruelly.

Fans and philosophy

Given what academics have noted as reasons for the Borg's popularity, it is worth noting what fans have to say. In some chat rooms, there is a consensus that the Borg should not be hunted down due to their moral agency. Only in the face of imminent danger, or even the extinction of humanity, do some fans, such as the ones on the *Trekspace.com* 'Killing the Borg' discussion board, advocate the annihilation of the cybernetic culture.

In fact, there are a number of fans who express a desire to be Borg, some on a permanent basis and some only for a brief period. To these Borg sympathizers, the allure of being Borg has to do with the immediate consequences of assimilation, namely the end of societal ills such hatred, bigotry, hunger and war. One fan, using the pseudonym nth-drone, commented in 2008 on the 'To be Borg or not to be Borg [...] that is the question!' discussion board on the benefits of being a part of the Borg collective:

[I have] thought about this on and off for quite some time now, and I think I would do it. I mean, how awesome would it be to have one way of doing things and one way of thinking? There will be no bigotry or hatred. Everyone will be working together for a common goal: Perfection. There would be no need for schools because the collective consciousness and intelligence of thousands of species will become a part of who you are.

The fan's consequentialist attitude is evident in his description of how the Borg represent a desired state, namely the lack of hatred and bigotry and the achievement of harmony. Another fan using the pseudonym Thorius on the 'Borg – any volunteers' discussion board (2012) admitted that not all aspects of the Borg were desirable and wanted by all fans, but there are still many who would be Borg permanently.

The *Trek* writers seem to consider the Borg to be one of the ultimate scary possible fates for a human, but if [there is] one thing I know about humans, [it is] that all sorts of people react differently to different possibilities. There has to be [sic] at least some humans who would consider it to be a cool opportunity to join the Borg.

In addition to the allure of collectivism, some fans say they envy the Borg for the mechanical augmentations afforded to every newly-assimilated individual. One fan on a particular Trek BBS discussion board relished the thought of being fitted with Borg computer chips capable of enhancing the fan's ability to quickly do mathematical computations. Other fans in the same discussion forum lauded the medical benefits of being Borg, such as the use of nanotechnology to expedite the healing process and the use of advanced prosthesis for the physically disabled.

The Borg: Fan Pariah or Cultural Pillar?
Charles Evans Jones, Jr

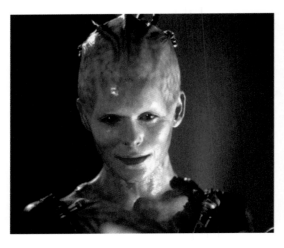

Fig. 2: The Borg Queen, played by Mary Krige, in Star Trek: First Contact. Image © Paramount Pictures.

Sentience and humanization in 'I, Borg'

Initially aired on 11 May 1992, during *ST: TNG*, 'I, Borg' begins with an away team from the starship USS *Enterprise* investigating a crash site of a Borg vessel on a nearby uninhabited planet. During the investigation of the site, Dr Crusher, the ship's medical physician, happens upon a nearly lifeless Borg drone and requests that the survivor be brought aboard the *Enterprise* where it could receive necessary medical assistance. Picard, the ship's captain, decides to treat the surviving drone as both a serious threat and as a potential weapon. As a result, he orders Engineer Geordi LaForge to create an invasive computer virus that would completely disable Borg systems. The recently rescued Borg, named Third of Five, would serve as the initial recipient of the new program. Within the time it takes to develop this virus, several crew members grow fond of the drone, especially LaForge. Eventually Picard decides to abort the plan and allow Third of Five to return to the collective with his newfound individuality intact, hoping that the drone would teach other Borg drones to be individuals as well. A critic interested in explaining both the Borg's MAC nature and popularity with fans is drawn to two themes: the respect for sentience and the humanization of an alien other.

The first example of respect for sentience occurs at the crash site at which the Borg survivor was found. After Crusher finds him, she and the rest of the away team are ordered by the captain to return to the *Enterprise*. As *The Star Trek Encyclopedia* notes, Crusher's insistence she be allowed to try to save the surviving Borg drone evinces her unbending commitment to her medical ethics, namely the values set forth by the Hippocratic oath. Another example of the theme of sentience occurs when Dr Crusher is in a senior staff meeting on the *Enterprise* deliberating the use of the rescued Borg drone as an instrument of genocide. During the meeting, tension rises over the question of the Borg's human nature. Crusher says:

When I look at my patient, I [do not] see a collective consciousness [...] I [do not] see a hive [...] I see a living, breathing boy [...] [who has] been hurt and who needs help. And [we are] talking about sending him back to his people as an instrument of destruction.

In a third scene, upon waking up in the brig of the *Enterprise*, the drone appeared bewildered and slightly disoriented as if hungry. Crusher informed Picard and LaForge that the Borg do not ingest food but rather energy which they then convert into the necessary organic molecules to sustain themselves. Later, Crusher expresses her disagreement with LaForge's attempts at rationing the drone's energy supply. LaForge argues that it is a matter of gaining the drone's compliance and that his actions are warranted given that the Federation is in war against the Borg. Crusher acknowledges LaForge's

perspective but tells him '[I am] here to help you, but I [do not] have to like it.' Crusher's consistency in these scenes was a major factor in Picard's eventual decision to abort the development of the invasive program on the grounds of the Borg drone's newfound individuality.

In addition to examples of sentience, there are many cases of humanization in 'I, Borg' involving the conditioning of the Borg drone to use the personal pronoun 'I' instead of 'we'. The first example occurs after Crusher's insistence they 'feed' the drone. LaForge alienates the Borg drone (i.e. making it feel like an other or an outsider) all the while disputing its usage of the personal pronoun 'we' instead of 'I'. The drone's silence indicates its uncertainty as to an appropriate response. It seems as though LaForge has planted the seed of humanity within the Borg drone as it contemplates the values of its new environment. Another example of humanization takes place in the science lab, where LaForge works with Crusher to gather information from the Borg drone needed to construct the invasive computer program. The humanization occurring in this scenario involves the rescued Borg drone's being introduced to the foreign concept of a 'doctor'.

Attempts at humanizing the rescued Borg drone continue in the science lab as LaForge tries to break Third of Five's habit of using the personal pronoun 'we' to describe himself. In order to do so, LaForge gives the drone a new name, Hugh, to replace the cyborg's former designation. Such an act can be considered humanizing because LaForge imposed his cultural, human values which privilege names over the functional, numerical-based Borg designations. LaForge attempts to explain to Hugh the significance of conceiving one's self in the singular rather than the plural:

Every time you talk about yourself, you use the word 'we'. We do this, we do that … you [do not] know how to think of yourself as a single individual. You [do not] say, 'I want this,' or 'I am Hugh.' [...] We are all separate individuals. I am Geordi. I choose what I want to do with my life. I make decisions for myself. For people like me, losing that individuality – is almost worse than dying.

Later, Picard, interested in testing the bounds of Hugh's newfound individuality, tells the drone that LaForge will be assimilated and that Hugh will assist him in the effort. Hugh responds, 'I will not assist you.' Picard invokes the drone's commitment to duty, countering, 'you are Borg.' But Hugh is defiant: 'No, I am … Hugh.' Hugh's experiences with humanization highlights his MAC philosophy: since LaForge will not benefit from the assimilation policy, he should not be subjected to it. Similarly, it was difficult for him to comprehend the concept of a doctor, because in Borg society irreparably injured or deceased drones are reabsorbed, as explained in the *ST: TNG* episode 'Q Who' (Episode 16, Season 2). As far as the Borg are concerned, the dead and irreparably injured have outlived their purpose – to help the collective achieve their goals. Not surprisingly, the

The Borg: Fan Pariah or Cultural Pillar?
Charles Evans Jones, Jr

medical treatment Hugh received came to him as a shock.

Here one notices the stark philosophical difference between the Federation and the Borg collective. The Federation values the lives of individuals as means in and of themselves (i.e. a Kantian perspective) and the Borg treat them as a means to an end (i.e. a MAC perspective). Similarly, the Borg's MAC moral philosophy is evidenced by the theme of sentience, particularly when Picard reveals his desires to use Hugh as an instrument of genocide during the senior staff meeting. During the meeting Picard noted that the Borg are relentless, claiming that they have attacked the Federation's way of life and that there is no chance of any conciliatory relations. The Borg on the other hand view the Federation – its ships and personnel – as capable of adding to their distinctiveness in some capacity. Such reason is enough to warrant the Borg's decision to assimilate the Federation whenever an opportunity presents itself.

Fan comments on 'I, Borg' reveal an understanding of the larger moral undertones of Borg assimilation practices as well as the difficult position Picard and the crew were placed in, given the potential opportunity to eliminate a dangerous adversary. In 2011, fan Zack Handlen summed it up: 'The episode overall does a fine job of giving us yet another tricky ethical problem.' It is apparent that this fan had considered the moral dilemma underlying the plot of the episode: turn Hugh into an instrument of destruction against his own people, or release him and risk further attacks upon the Federation. Fans seemed to grasp the general concept of consequentialism, though its finer points remained elusive to some. But the willingness of some to continue to embrace the Borg, aware that at least some of the contentiousness between them and the Federation is philosophical in nature, has implications both for our understanding of *Star Trek* fans and for citizenship more broadly.

A rift in fandom or larger social debate?

This chapter has argued that the Borg's assimilation practices are the result of a MAC moral philosophy and that fans like the Borg because of that philosophy. It should be said that this chapter does not seek to paint a rosy picture of the Borg as a wholly benevolent civilization. They are far from it. Neither does this chapter suggest that the Borg should shed its role as a villain and be made the main focus of the *Star Trek* media franchise. To a culture accustomed to rooting for 'good-guy' protagonists, that would be ludicrous. Instead, much of what this chapter does is explains that the Borg are not morally the easily classifiable black-and-white characters they at first appear to be. They are shades of grey for a subculture of fans that see the Borg as more than mere supporting characters.

Given that the *Star Trek* cultural franchise for many always has stood for utopian ideals made concrete in a far-off future they have little chance of actually living in, it is not surprising that the Borg would represent an alternative vision of the future, one that dramatically strays from the Federation's Kantian outlook. Interestingly, fan support associated with the Borg and their MAC philosophy indicates a conscious rejection of the

Federation's mainstream ideals, many of which focus more on the ethicality or rightness of the means more so than the ability to achieve a particular end. Such dissatisfaction with the Federation by Borg fans may mirror the frustration of some US citizens with the seeming paralysis and pettiness of representative government. Just as frustrated democratic societies through history have occasionally put their faith in totalitarian regimes who promise sought-after ends whatever the means, perhaps the stalemates derived from political partisanship have driven many Borg fans to look elsewhere for symbols of successful collective action. Unfortunately, in looking to the Borg as a model for successful collective action, many fans are taken for communists or socialists, labels made pejorative by entrenched capitalist interests for their supposed opposition to the democratic ideals of individualism. In this way, these fans marginalize themselves be seeming to hold anti-patriotic or heretical views.

Even if the Borg remain largely the evil antagonists of the *Star Trek* universe, they likely also will remain a cultural pillar among *Star Trek* fans for years to come. Like Sherlock Holmes's Moriarty, they are a relentless, resourceful, and yet necessary 'evil' that cannot easily be defeated and with a moral philosophy that, if not entirely pro-social, at least successfully rivals that of the protagonists in its consistency and logic. The Borg's rival philosophical outlook on right and wrong reflect the very people who proudly call themselves fans. Such a Borg following connotes a moral diversity amongst the oft-monolithically-conceived *Star Trek* 'fan'. Fans of the Borg are different, and their alternative perspective about how utopia may best be achieved deserves to be heard, debated and recognized for its uniqueness. Just as both totalitarian and democratic societies seek order and a common good, both Borg fans and Federation fans want galactic peace and harmony. The big difference between the two camps thus is not ends, but means. ●

GO FURTHER

Books

The Elements of Moral Philosophy (7th edn)
James Rachels and Stuart Rachels
(Boston, MA: McGraw-Hill, 2012)

The Fundamentals of Ethics
Russ Shafer-Landau
(New York: Oxford University Press, 2011)

Drones, Clones, and Alpha Babes: Retrofitting Star Trek's *Humanism, post-9/11*
Diana M. A. Relke
(Alberta: University of Calgary, 2006)

The Borg: Fan Pariah or Cultural Pillar?
Charles Evans Jones, Jr

The Blackwell Dictionary of Western Philosophy
Nicholas Bunnin and Jiyuan Yu
(Malden, MA: Blackwell Publishing, 2004)

Race in Space: The Representation of Ethnicity in Star Trek *and* Star Trek: The Next Generation
Micheal C. Pounds
(Lanham, MD: Scarecrow Press, 1999)

The Star Trek Encyclopedia: A Reference Guide to the Future (2nd edn)
Michael Okuda and Denise Okuda
(New York: Pocket Books, 1997)

Star Trek: *The Human Frontier.*
Michele Barrett and Duncan Barrett
(New York: Routledge, 1992)

1984
George Orwell
(New York: New American Library, 1981 [1949])

Extracts/Essays/Articles

'Some forms and limits of consequentialism'
David O. Brink
In David Copp (ed.). *The Oxford Handbook of Ethical Theory* (New York: Oxford University, 2006), pp. 380-422.

'Borg babes, drones, and the collective: Reading gender and the body in *Star Trek*'
Mia Consalvo
In *Women's studies in Communication*. 27: 2 (2004), pp. 178-203.

'*Star Trek: First Contact*: The hybrid, the whore, and the machine'
Christine Wertheim
In Ziauddin Sardar and Sean Cubitt (eds). *Aliens R Us: The Other in Science Fiction Cinema* (London: Pluto Press, 2002), pp. 74-93.

'The moral significance of collective entities'
Keith Graham
In *Inquiry*. 44: 1 (2001), pp. 21-42.

Television and Film

'I, Borg'
Robert Lederman (dir.)
Star Trek: The Next Generation (Hollywood, CA: Paramount, 11 May 1992)
'Q Who', Rob Bowman, dir., *Star Trek: The Next Generation* (Hollywood, CA: Paramount, 6 May 1989)

Online

'Borg-any volunteers?'
Thorius (pseud.)
Trekbbs.com. 17 March 2012, http://www.trekbbs.com/showthread.php?t=166432

'"I, Borg," Or the one where a real tin man gets a heart and a brain'
Z. Handlen
The A.V. Club. 5 May 2011, http://www.avclub.com/articles/i-borgthe-next-phase,55495/

Killing the Borg
M. Connolly
Trekspace.com. 19 March 2008, http://www.trekspace.org/group/theborgcollective/forum/topics/
1977635:Topic:9113

'Assimilation: what's so bad about it ... really?'
Admirallukehart (pseud.)
Trekspace.com. 16 March 2008, http://bit.ly/13nIMSh
'To be Borg or not to be Borg ... That is the question!'
Nthdrone (pseud.)
Trekspace.com. 13 March 2008, http://bit.ly/12fBGYK

'I, Borg' [teleplay]
Jeri Taylor
Star Trek Minutiae. July 2010, http://www.st-minutiae.com/academy/literature329/223

Contributor Details

EDITOR

Bruce E. Drushel is an associate professor in the Department of Communication at Miami University. He chairs the Gay, Lesbian & Queer Studies interest group for Popular Culture Association/American Culture Association and in 2012 received its Charles Sokol Award for his service to the organization. He is co-editor of the books *Queer Identities/Political Realities* (Cambridge Scholars Publishing, 2009) and *Ethics of Emerging Media* (Continuum, 2011). His work also has appeared in *Journal of Homosexuality*, *Journal of Media Economics*, *European Financial Journal* and *FemSpec*, and in books addressing free speech and social networks, free speech and 9/11, media in the Caribbean, C-SPAN as a pedagogical tool, LGBTQ persons and online media, minority sexualities and non-western cultures, and AIDS and popular culture. He currently is editing a special issue of *Journal of Homosexuality* on AIDS and Culture and shortly will begin co-editing a special issue of *Journal of American Culture*.

CONTRIBUTORS

Paul Booth is an assistant professor of New Media and Technology at DePaul University. He received his Ph.D. in Communication and Rhetoric from Rensselaer Polytechnic Institute. He researches new media, technology, popular culture, and cultural studies and teaches in the areas of media studies, television narrative, convergence and digital media, popular culture, social media, communication technology, and participatory cultures. He is the author of *Digital Fandom: New Media Studies* (Peter Lang, 2010), which examines fans of cult television programs. He has also published articles in *Communication Studies*, *Transformative Works and Culture*, *Television and New Media*, *Critical Studies in Media Communication*, *New Media and Culture*, and in several anthologies. His newest book, *Time on TV: Temporal Displacement and Mashup Television*, was published by Peter Lang Publishing in May 2012.

Michael Boynton is currently a doctoral candidate at the University of Maryland, College Park, at the School of Theatre, Dance and Performance Studies. He also holds a MFA from NYU Tisch in musical theatre writing and a MFA from WSU in classical acting. Scholarly interests include performance and critical identity theory, linguistics, verse drama, Shakespeare, musical theatre, avant-garde performance, and game studies. Michael's dissertation-in-progress addresses the performance and performativity of the contemporary American 'nerd' identity. A professional writer and actor, Michael has worked both on and off Broadway, regionally and internationally. He is also artistic director of Pallas Theatre Collective.

Cait Coker is Assistant Professor of Library Science and the curator of the Science Fiction Research Collection at Texas A&M University. Her research interests focus on the history and depiction of women and sexuality in science fiction. Recent scholarship includes 'Does the Doctor Dance? Heterosexuality, Omnisexuality, and Spontaneous Generation in the Whoverse' in the volume *The Unsilent Library: Essays on the Russell T. Davies Era of the New Doctor Who* (Science Fiction Foundation, 2011); 'The Friends of Darkover: An Annotated History and Bibliography' in *Foundation, The International Review of Science Fiction* (2008); and the forthcoming article 'Earth 616, Earth 1610, Earth 3490 – Wait, What Universe is This Again?: The Creation and Evolution of the Avengers and Captain America/Iron Man Fandom' in *Transformative Works and Cultures*.

Kenneth Huynh is a Ph.D. candidate at the Ontario Institute for Studies in Education at the University of Toronto. Broadly speaking, his research interests include Asians in the diaspora, theories of discourse, and political economies of affect. His present research project examines Asian Canadians, strategies of representation, and the emotional consequences of racial activism against the backdrop of neo-liberal multiculturalism. In no particular order, his favourite Asians on *Trek* are Sulu, Harry Kim and Data (sociologically speaking, Data should count).

Charles Evans Jones Jr is pursuing an MA in Communication Studies with a focus in organizational and professional communication development at Ball State University. He completed his BA in Communication at DePauw University in Greencastle, Indiana in 2010. His case study, 'The cost of entrée: A case study on non-White students' cross-racial membership in White Greek-letter organizations' has been accepted at two student symposia at Ball State.

Kimberly L. Kulovitz is a fourth-year doctoral student in the Department of Communication at the University of Wisconsin-Milwaukee, where her research interests include interpersonal relationships, bullying and cyberbullying, and communication in gaming and popular culture. Mrs Kulovitz's recent publications include 'The Games We Play: Review of Tom Bissel's Extra Lives' (*Journal of Popular Culture*, February 2012) and 'Cyberbullying: Perceptions of Bullies and Victims' (*Misbehavior Online in Higher Education*, 2012).

Bianca Spriggs is a multidisciplinary artist who lives and works in Lexington, Kentucky. Currently a doctoral student at the University of Kentucky, she holds degrees from Transylvania University and the University of Wisconsin. Bianca is a 2012 Pushcart Prize nominee, and a recipient of multiple Artist Enrichment and Arts Meets Activism grants from the Kentucky Foundation for Women. In partnership with the Kentucky Domestic Violence Association, she is the creator of 'The SwallowTale Project', a travelling crea-

tive writing workshop designed for incarcerated women. Bianca Spriggs is the author of *Kaffir Lily* (Wind Publications, 2010) and *How Swallowtails Become Dragons* (Accents Publishing, 2011).

Elizabeth Thomas is a lecturer in the Journalism & Mass Communications Department at Murray State University. She holds a MSc in Mass Communications from Murray State and a BSc in Advertising from the University of Florida. Her research includes 'DVR Pilot Study: Uses and Gratifications of Digital Video Recorders in Modern Television Viewing', in the *Journal of Mass Communication & Journalism* (2012), and presentations to the Popular Culture Association/American Culture Association national conference. She is editor of the books, *A History of the Royal Bahamas, its Politics and Police, 1880–1990*, published by the Royal Bahamian government in 1991 and *Adopting in America: The Diary of a Mom in Waiting* (CreateSpace, 2011). She also operates a social media consultancy and publishes a daily weblog.

Nathan Thompson is a Ph.D. student at the Ontario Institute for Studies in Education and the Mark S. Bonham Centre for Sexual Diversity Studies at the University of Toronto and he is currently an instructor at the University of New Brunswick. His research project looks at the production of social difference and social categories within rural Canadian schools. His research interests include sexual and gender minority rights, education as cultural production, and questions around community and belonging. His favourite possession is an autographed picture of Marina Sirtis (Deanna Troi) which reads, 'To Nathan: With feelings of great joy and gratitude, great joy and gratitude.' (See Episode 1, Season 1: 'Encounter at Farpoint, Pt. 2'.)

Image Credits

Additional Images

Introduction: Fig. 1 p.5 © Virgin Galactic

Chapter 1 Fig. 1 p.12 © Paramount Pictures

Chapter 2 Fig. 1 p.21 © Paramount Pictures from Star Trek: Enterprise
(exec. prod. Rick Berman, Brannon Braga, Manny Coto)
Fig. 2 p.25 © Paramount Pictures from Star Trek (dir. J.J. Abrams)

Chapter 3 Fig. 1 p.31 © Paramount Pictures
Fig. 2 p.34 © JustJared.com

Chapter 4 Figs. 1-3 p.43 & p.46 © Michael Boynton

Chapter 5 Fig. 1 p.53 © Paramount Pictures from Star Trek: Enterprise
(exec. prod. Rick Berman, Brannon Braga, Manny Coto)
Fig. 2 p.57 © Paramount Pictures from Star Trek: The Next Generation
(exec. prod. Gene Roddenberry, Maurice Hurley, Rick Berman, Michael Piller, Jeri Taylor)

Chapter 6 Fig. 1 p.63 © USA Today
Fig. 2 p.66 © Gary Goddard Entertainment + Design
Fig. 3 p.68 © WilliamShatner.com

Chapter 7 Fig. 1 p.73 © Dreamworks, LLC, from Galaxy Quest (dir. Dean Parisot)
Fig. 2 p.76 © Dreamworks, LLC, from Galaxy Quest (dir. Dean Parisot)

Chapter 8 Fig. 1 p.83 © Paramount Pictures from Star Trek (exec. prod. Gene Roddenberry)
Fig. 2 p.86 © CBS Studios

Chapter 9 Fig. 1 p.93 © Paramount Pictures from Star Trek: The Next Generation
(exec. prod. Gene Roddenberry, Maurice Hurley, Rick Berman, Michael Piller, Jeri Taylor)
Fig. 2 p.96 © Paramount Pictures from Star Trek: First Contact (dir. Jonathan Frakes)

LIVE
LONG
AND
PROSPER.

MR. SPOCK
STAR TREK: THE MOTION PICTURE

FAN PHENOMENA

OTHER TITLES AVAILABLE IN THE SERIES

Batman
Edited by Liam Burke
ISBN: 978-1-78320-017-7
£14.95 / $20

Star Wars
Edited by Mika Elovaara
ISBN: 978-1-78320-022-1
£14.95 / $20

Doctor Who
Edited by Paul Booth
ISBN: 978-1-78320-020-7
£14.95 / $20

Buffy the Vampire Slayer
Edited by Jennifer K. Stuller
ISBN: 978-1-78320-019-1
£14.95 / $20

Twin Peaks
Edited by Marisa C. Hayes
and Franck Boulegue
ISBN: 978-1-78320-024-5
£14.95 / $20

For further information about the series
and news of forthcoming titles visit **www.intellectbooks.com**